photographing
wilderness

Jason Friend

photographing wilderness

Jason Friend

GUILD OF
MASTER CRAFTSMAN
PUBLICATIONS

First published 2003 by
Guild of Master Craftsman Publications Ltd,
166 High Street, Lewes,
East Sussex, BN7 1XN

Publisher: Paul Richardson
Art Director: Ian Smith
Production Manager: Stuart Poole
Managing Editor: Gerrie Purcell
Commissioning Editor: April McCroskie
Editor: Clare Miller
Designer: Geoff Francis

A catalogue record of this book is available from the British Library.
Typeface: Headings and captions Univers, bodycopy Garamond.
Colour origination by Graphics Kent
Printed and bound by Stamford Press Pte Ltd, Singapore

Acknowledgements

This book would have not been possible without the assistance and input of many people.
I would like to give personal thanks to my editor,
Clare Miller, for her advice and support during the project,
April McCroskie for her initial foresight and guidance and the whole team at
GMC Publications for making this book a reality.
I am indebted to Kiwi photographer, Shaun Barnett, for his image contributions to the
'Pristine Wilderness Locations' chapter, as well as for the inspiration his own work has
provided me over the years.
A big thank you to Sal Sheul at Collections for her professional advice and encouragement,
all the staff and directors at F.E. Maughans for their assistance and flexibility, Steven
Turner, Jason Haynes and my other good friends from the Midlands for their
encouragement during this project, as well as Penny, Roy and Mark Whitehouse
for their belief and support.

◆

I would probably never have become a photographer
if it wasn't for the kick-start from my dad, John Friend,
who gave me my first SLR a couple of weeks before a trip to Mexico
and my mom, Carol Friend, for her encouragement throughout the years.
An extra special thank you goes to my long-term partner, Lynette Whitehouse,
for her support and unconditional belief,
as well as the proofreading of this book,
accompanying me on most of my trips into the wilderness,
being a perfect model for the 'Human Touch' chapter
and also for carrying the tent on many overnight stays!

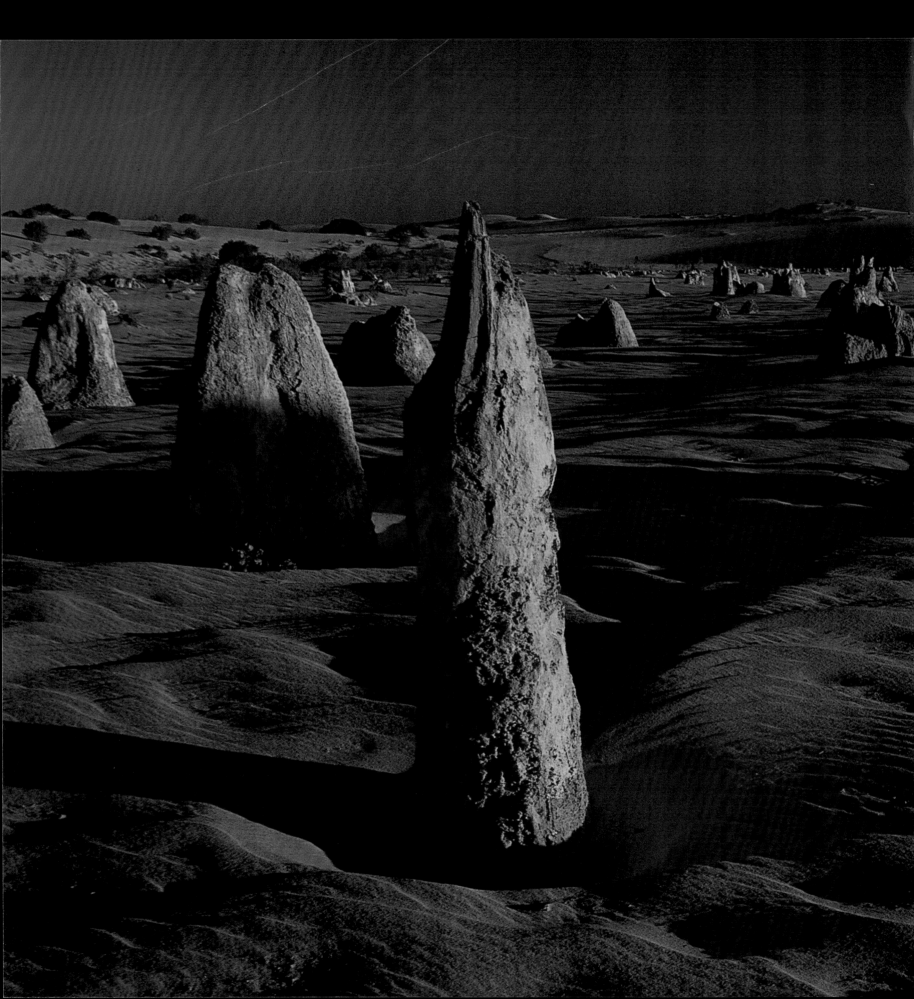

Contents

The Pinnacles Desert,
Nambung National Park,
Western Australia

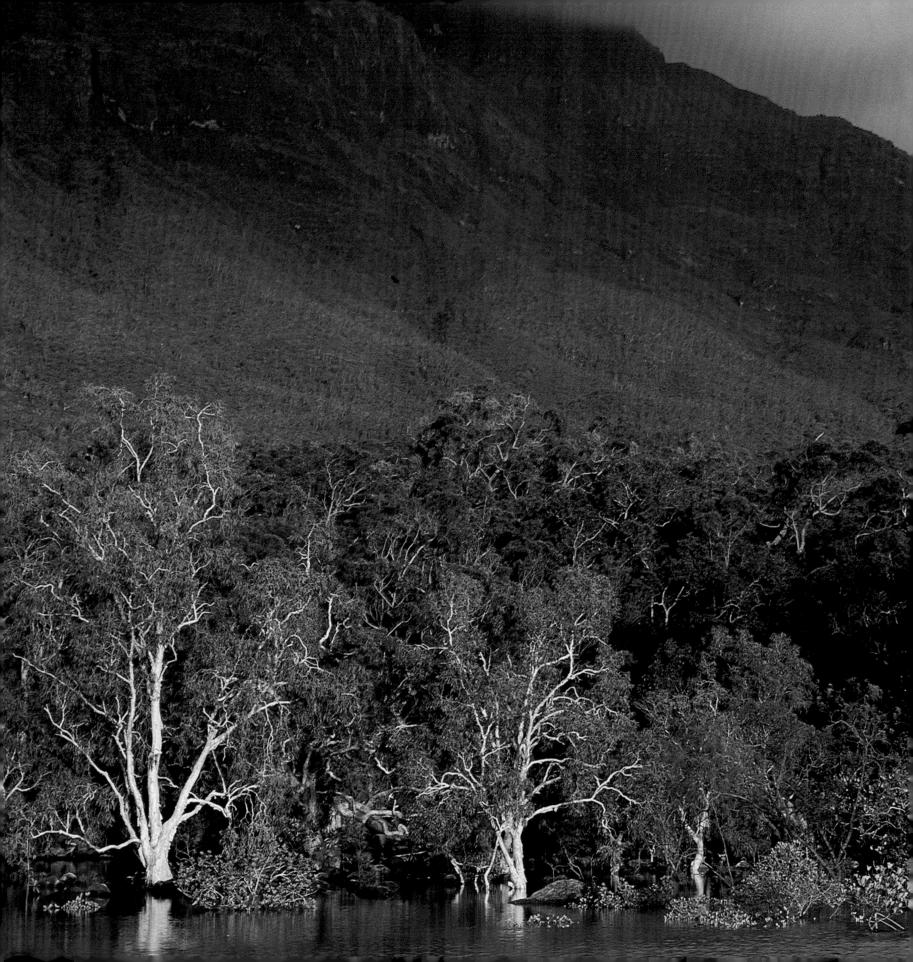

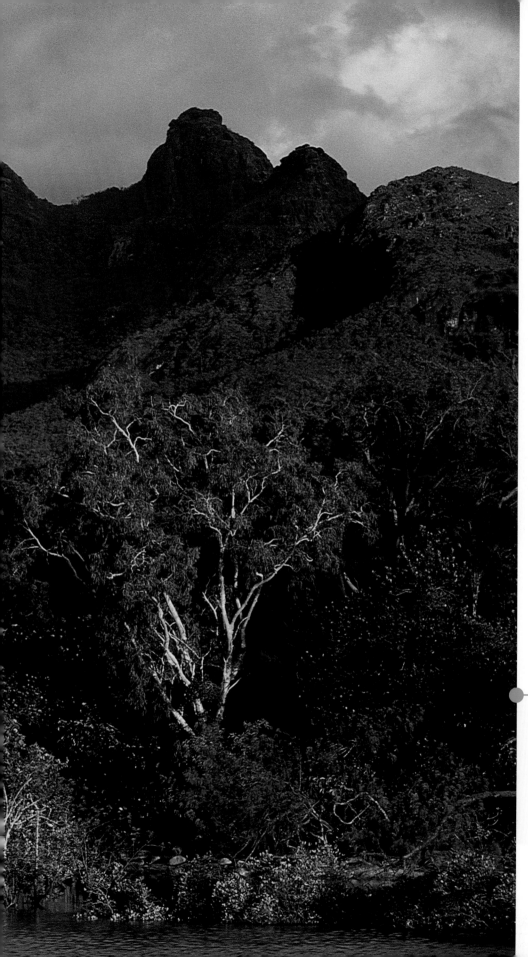

Welcome to the wilderness

Our planet is comprised of a huge diversity of environments. It is a place with an immense human population, abundant with bustling cities whose inhabitants lead a hectic existence. However, it is also home to stunning areas of natural beauty, as yet unimpaired by man's gradual infringement on his surroundings. For many, this world is only available through books, magazines and television documentaries, but for those who seek it, wilderness is often more attainable than it might appear.

Hinchinbrook Island National Park, Queensland, Australia – 1/2sec at f/19, 28–70mm lens, polarizing filter, tripod, Canon EOS 300

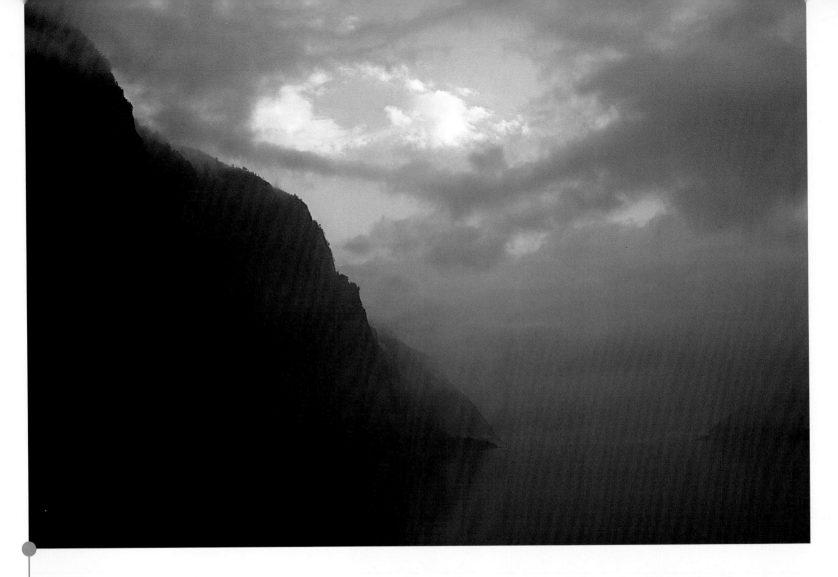

The ultimate objective of the wilderness photographer is to capture an image which is pictorially pleasing as well as conveying the true essence of a place – the real character behind the landscape.
Aurlansfjordan, Norway – 1/8sec at f/19, 35–80mm lens, tripod, Canon EOS 300

Be it a small patch of woodland close to your home, or one of the many spectacular national parks located near some of the world's largest cities, there are many and varied wilderness locations available. Los Angeles, USA, is a good example with the wild Santa Monica National Park being only a short drive away from hectic city life. Another is Nikko National Park, just a brief train journey from the Japanese city of Tokyo. Wherever you live and whatever country, there will more than likely be a place where solitude and some degree of wilderness can be found.

How we actually perceive wilderness depends on our own individual way of thinking. However, laws have now been passed in many countries that provide a definition of wilderness in order to protect it. The National Wilderness Preservation System in the USA defines it as landscape that is uninhabited and unscarred by mankind, or 'Where the earth and its community of life are untrammelled by man, where man himself is a visitor who does not remain'.[1]
The Wilderness Society of Australia uses similar criteria, describing it as, 'a remote area essentially unaffected and unaltered by modern industrial civilisation'.[2]

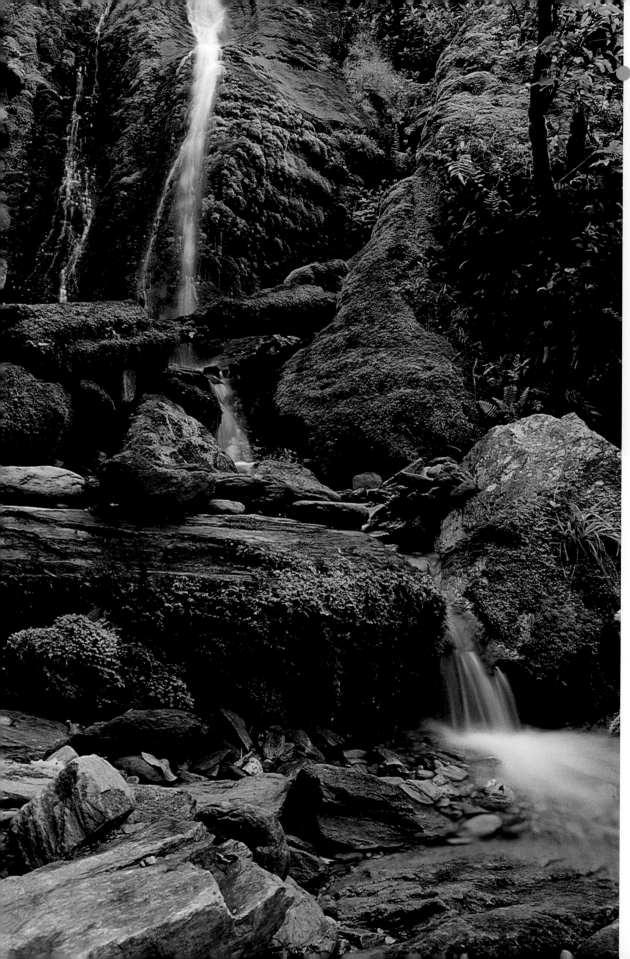

The photographer that ventures off the beaten track will often be rewarded with a memorable photographic opportunity. This tranquil waterfall was found by taking an overgrown sidetrack running from the popular Queen Charlotte track in New Zealand. **Marlborough, New Zealand – shutter speed not recorded, at f/19, 24mm lens, polarizing filter, tripod, Canon EOS 600**

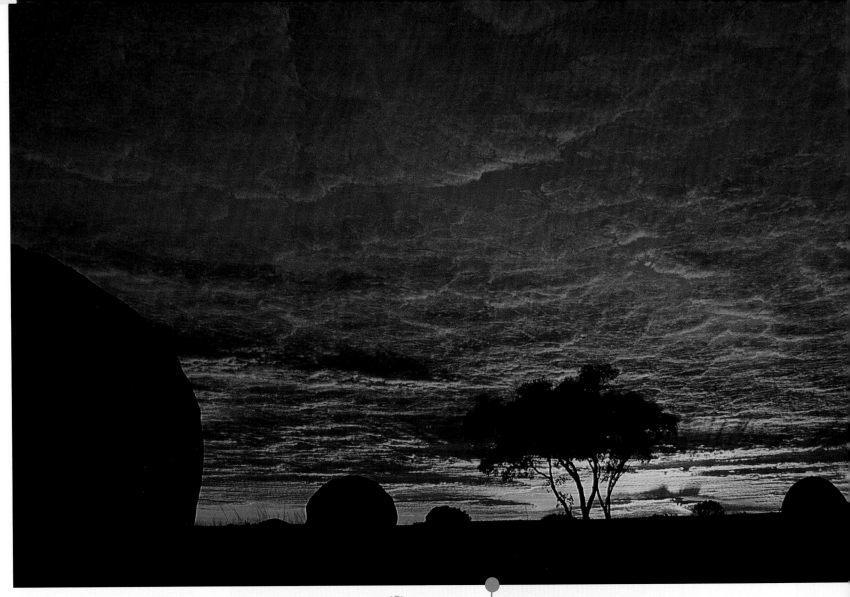

It was on an overnight hike in the Jotunheimen National Park, Norway, that I witnessed one of the most unusual sights I have ever seen on a trip to the wilderness – the Northern Lights or *Aurora Borealis*. My partner Lynette and myself had hiked to a suitable camping spot and then pitched the tent. We were miles from the nearest signs of civilization and even more importantly miles from any light pollution. Owing to the exhausting hike, we had fallen asleep relatively early, meaning an unavoidable toilet trip in the middle of the night. We were greeted by an amazing array of dancing lights across the clear Norwegian sky. I was tempted to reach for my camera but then decided against it. It is important to know when to take a photograph and when to just enjoy the experience.

Setting the alarm for an unearthly hour is a regular occurrence for the wilderness photographer. When combined with the right weather conditions and a dose of luck, an early morning photography venture can provide you with truly memorable images. The image shown here captures the various hues of the pre-dawn colours over the Australian outback.
The Devils Marbles, Northern Territory, Australia – 1sec at f/19, 35–80mm lens, tripod, Canon EOS 300

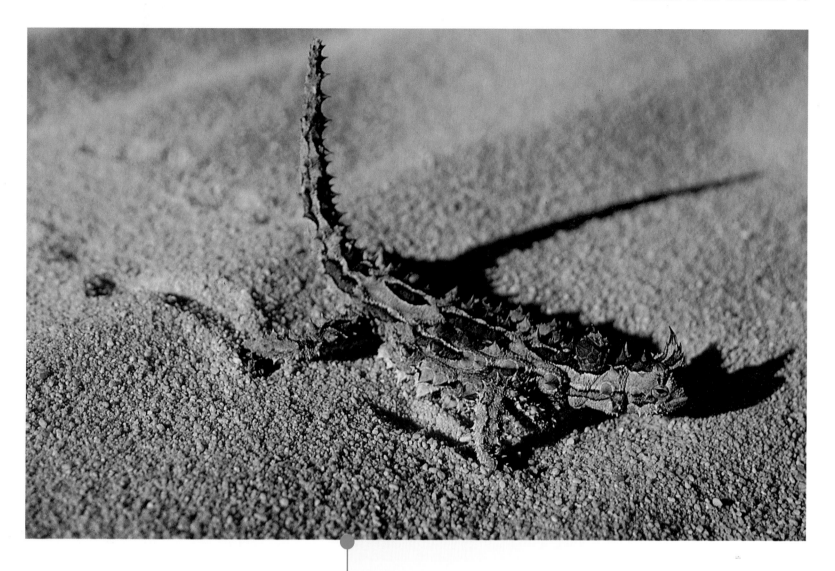

Visiting remote places can require extensive training and forward planning, as well as a measure of good luck. Considering this, it is only natural that those visiting such locations wish to capture images of these 'other worlds' to share with relatives and friends. Sometimes this desire will grow alongside one that strives to capture and portray the mood of the environment – the true essence of such a place. This could be considered to be the point where the wilderness photographer is born.

A wilderness photographer may often take advantage of a golden opportunity to capture a nature photograph. This unusual-looking lizard was spotted early one morning, basking on a dirt road linking the main access areas of the park.
I set my camera to 1/125sec in shutter priority mode and took the shot handheld.
I was using a slow film (ISO 50) but luckily the intense rays of the sun resulted in a small aperture, giving the final composition sufficient depth of field. Your trips into the wilds will bring you across many different inhabitants, and it is important to show respect to their homelands to which you are just a visitor. **Thorny Devil, Kalbarri National Park, Australia – 1/125sec, aperture not recorded, 35–80mm lens, Canon EOS 300**

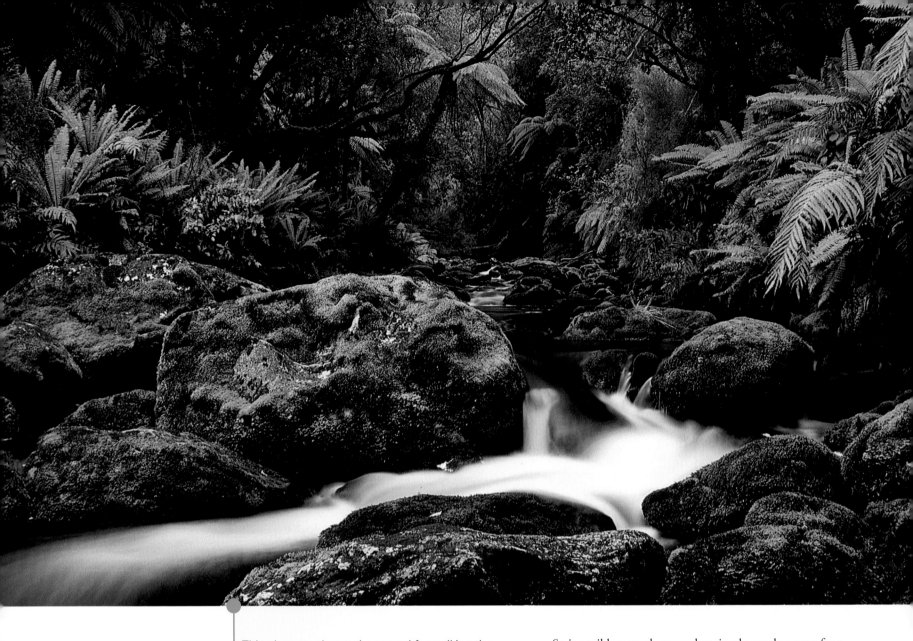

This photograph was the reward for walking the gruelling, 125-kilometre (77.5-mile) North-West Circuit track. The 11 day hike was a true test of endurance, following a muddy route along coast and through forest that has now become the Rakiura National Park.
Freshwater Stream, Stewart Island, New Zealand – 30sec at f/19, 24mm lens, polarizing filter, tripod, Cannon EOS 600

So is a wilderness photographer simply another term for a landscape photographer? The answer is both yes and no. The similarities are huge in terms of technique and style, but the wilderness photographer does not normally have the luxury of time or the option of numerous return visits when photographing a location. Access is also a major issue for the wilderness photographer as getting the desired shot can sometimes involve lengthy hikes, long drives or even chartering a light aircraft or boat. No matter how difficult a shoot is, it is important to remember good wilderness photography is effective in promoting the conservation of these areas. However, photography alone will never save

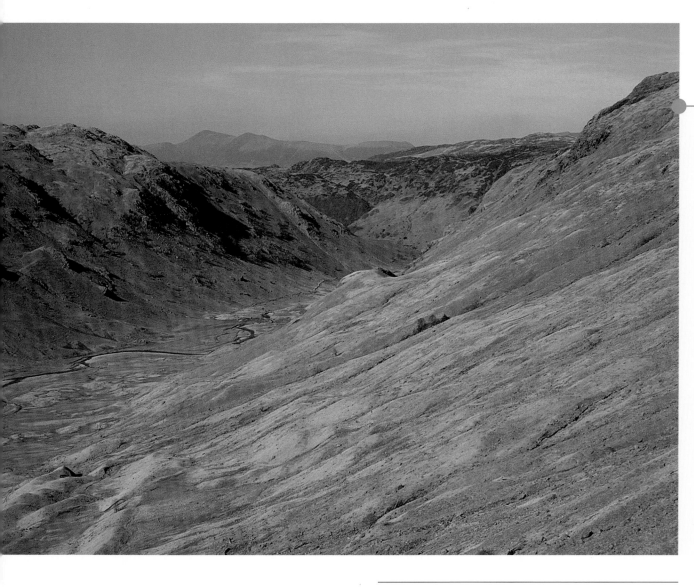

Many areas of the world have been designated as national parks, ensuring the protection of the landscape for future generations. The majority of these parks, including the Lake District National Park in England, offer golden opportunities for the wilderness photographer. **Stonethwaite Fell, Lake District National Park, England – 1/15sec at f/19, 35–80mm lens, combined 81A and polarizing filter, 0.3 neutral density graduated filter, tripod, Canon EOS 300**

such places and the photographer should not begin to take them for granted. If you respect the wilderness, your photographs will reflect your love of that location.

The dramatic beauty of the wilderness can be enjoyed and photographed by anyone who wishes to experience it. Welcome to the wilderness.

[1] *Taken from the Wilderness Act of 1964, which can be viewed at www.wilderness.net*

[2] *Taken from the website of The Australian Wilderness Society, which can be viewed at www.wilderness.org.au*

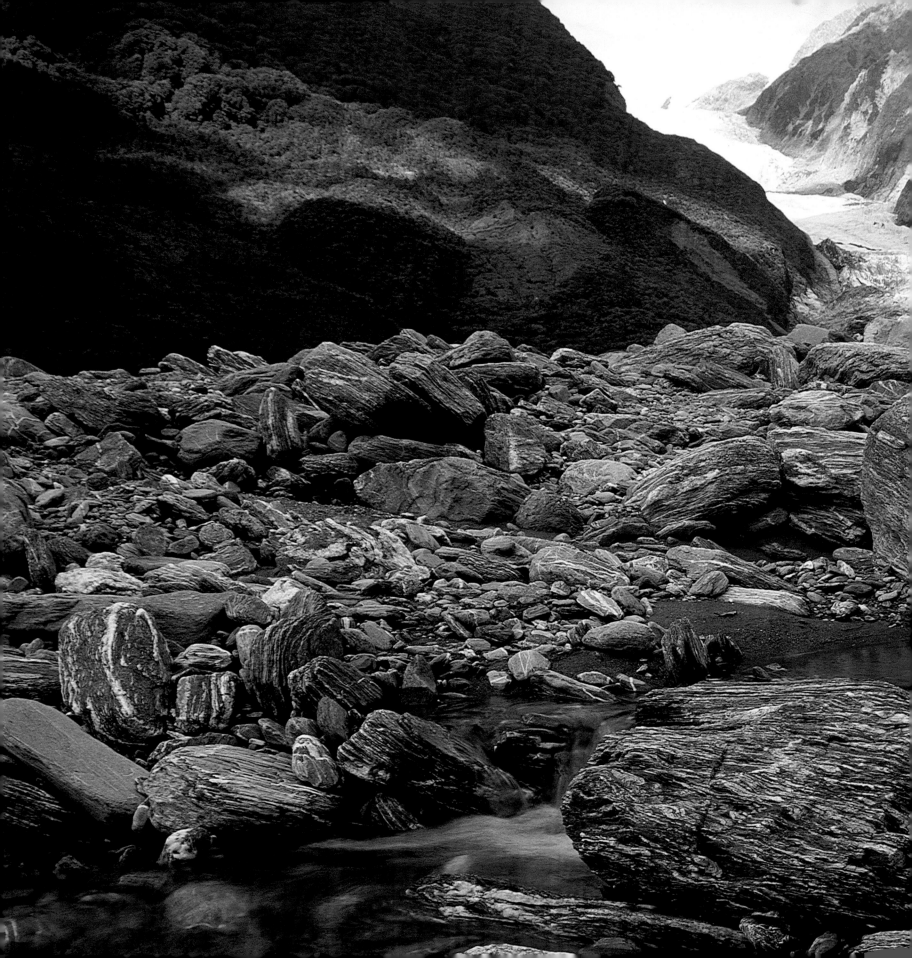

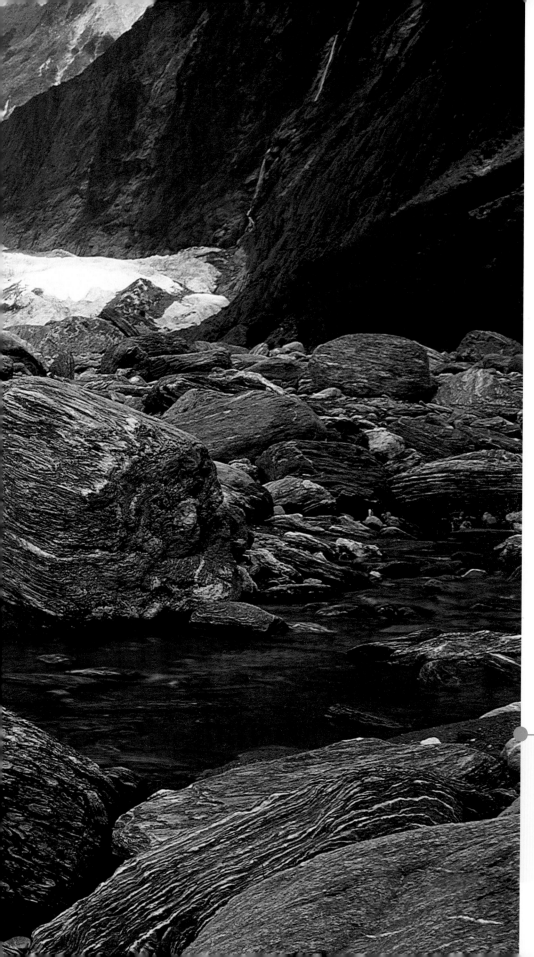

Choosing equipment

The camera is by no means the most important piece of equipment for the wilderness photographer to carry. Seeking images of remote locations often means a hostile working environment for the photographer. Your choice of equipment could effectively mean the difference between life and death so careful consideration is of the utmost importance.

Franz Josef Glacier,
Westland National Park,
New Zealand – 1/2sec at
f/19, 35–70mm lens,
polarizing filter, tripod,
Canon EOS 600

Clothing

Careful choice of clothing is essential for comfortable and safe photography in the wilds. High-quality hiking boots are imperative for anyone wishing to visit these areas of wilderness. A good pair of hiking boots will offer essential support to both the ankles and feet as well as providing a sound grip when walking on an unstable or rugged terrain. Footwear that encloses the foot will also offer some protection against bites from animals on the ground, such as snakes and scorpions, and will eliminate the possibility of insect bites to the feet. This latter is an important consideration as a bite from a mosquito on the foot or ankle can be particularly unpleasant, as well as introducing a risk of life-threatening diseases such as malaria or Ross River fever depending on your location.

Some consideration also has to be paid towards the choice of socks worn whenever wearing hiking boots. It is normally preferable to wear two pairs of socks – a thinner pair actually worn next to the skin coupled with an outer, thicker pair made of wool, or a synthetic material. This will reduce the chances of blisters occurring on the feet as well as helping to keep them warm.

It is vital to prepare yourself for cold weather conditions and thermals are particularly essential in alpine areas. Good thermals, such as those made from polypropylene, are breathable and quick drying, possessing a wicking property that allows moisture to move from the body's surface to the garment's outer layer. This means that by wearing thermals in wet weather you can greatly improve your comfort and

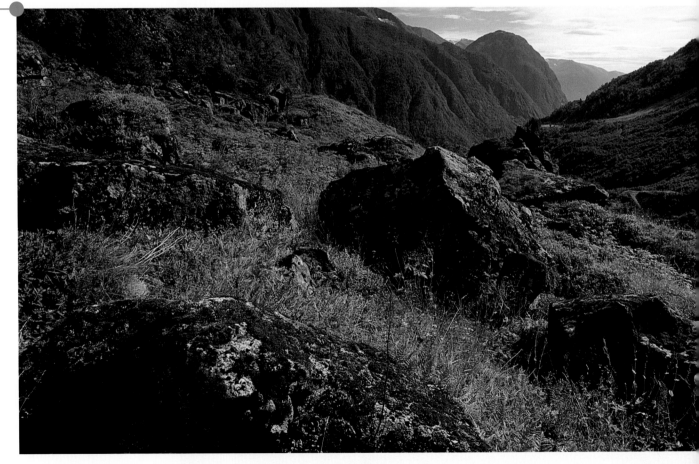

A good pair of hiking boots is essential for trips into the wilderness. Not only will they help to provide a good grip on loose or uneven terrain, they will protect and support the ankles, helping to reduce chances of injury.
Jostedalsbreen National Park, Sogn Og Fjiordane, Norway – 1/3sec at f/19, 24mm lens, combined 81A and polarizing filter, tripod, Canon EOS 300

maintain your body's core temperature; essential if hypothermia is to be avoided. The wilderness photographer tends to be working when the sun is at its weakest, and sometimes when it is not even present. Even the warmest of the earth's wild places, such as deserts, can be well below freezing before the sun has risen.

Hats and gloves should always be present in your rucksack. With over 50 per cent of the body's total heat being lost through the head, it is only sensible to cover up whenever you start to feel cold. Hands and fingers are also susceptible to low temperatures, making photography difficult and if the weather conditions are extreme, they could even be prone to frostbite. I carry a pair of gloves made out of light polypropylene that are thin enough to allow me

unrestricted use of my fingers – essential for operating a camera. If I am visiting alpine areas I also carry a second pair of gloves, the padded skiing variety, which help to keep my hands warm and dry when I am hiking to a location or simply waiting for good illuminating light.

TIP

A cold photographer is also an unproductive one so invest in some good quality thermal underwear!

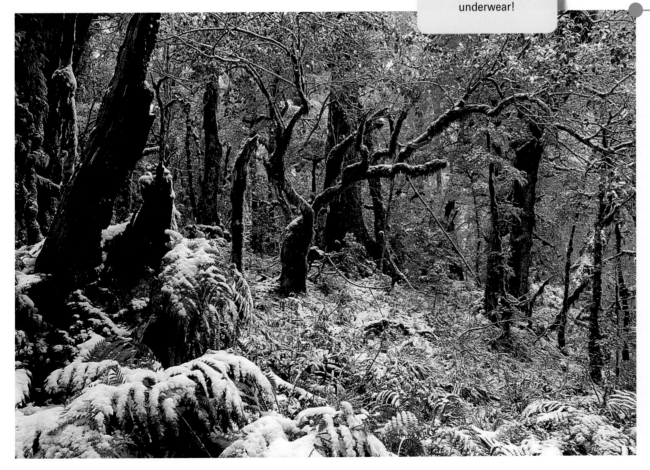

The cold is a killer. The working photographer must dress suitably to be prepared for both expected and unanticipated weather fronts. Apart from the physical effects of prolonged exposure to the cold, the hiking photographer will often have to deal with poor visibility and additional hazards such as snow and ice. **Te Urewera National Park, New Zealand – 2sec at f/19, 24mm lens, tripod, Canon EOS 600**

The choice of trousers worn is also an important factor to consider before heading to the wilds. In tropical conditions, shorts are normally adequate, and in some cases preferable, although this does depend on whether you visit in the wet or the dry season. When the latter is the case or if you are hiking in other areas, the ideal choice would be waterproof but breathable trousers. A problem long associated with waterproof trousers has been the lack of breathable fabrics, with the wearers' own perspiration actually making the legs damper than if waterproof trousers had not been worn. The key point when buying a pair of trousers is to buy a lightweight pair that will be suitable for year-round use, preferably manufactured by a good, recognized company.

If you do plan to walk within alpine areas, ensure that you buy a heavyweight pair of waterproof trousers and consider also wearing woollen or fleece trousers underneath. Another alternative would be the likes of trousers worn by skiers or snowboarders as these are designed for prolonged exposure to the elements.

The mid-layer for the torso is a straightforward choice. A light shirt can be worn next to the thermal layer, with the option of a woollen or fleece sweater worn over the top. My personal choice is to wear fleece as opposed to wool as I find that it is less likely to irritate the skin. I also wear a body fleece which helps to keep my body temperature constant without restricting the movement of my arms. My final layer for cold working conditions is a good quality hiking fleece. This is possibly one of the most important articles of clothing that the hiking photographer will purchase and as a general rule you should buy the best that you can afford.

Rain and snow is probably the scourge of the hiking photographer, making conditions difficult for navigating when hiking, although this is not the only problem this kind of weather can bring. To ensure your own safety you must always carry waterproof clothing, especially a good windproof and waterproof jacket. This is without doubt a lifesaver if the weather should happen to change for the worse. You must always keep yourself dry, no matter what kind of climate you may be working in.

While working at the Whakapapa ski-field within Tongariro National Park on the North Island of New Zealand, there were many days when I would be leaving for the upper slopes of Mt Ruaphu in glorious sunshine, only to have to return to the lower reaches of the mountain in a complete whiteout situation. Having experienced these harsh conditions, I fully appreciate the necessity of wearing the correct equipment when visiting alpine areas; especially hats, gloves and thermals. The latter may not be the most fashionable clothing accessory but they do help to maintain the body's core temperature and ultimately to save lives.

TIP

It is beneficial to buy a windproof fleece as this will improve the heat-trapping performance of nearly all of your layers of clothing.

When the cold is combined with wet weather, the wilderness photographer is at potential risk from hypothermia unless waterproof clothing is worn. Wind is also a contributor to hypothermia, so the middle or top layer of clothing should be windproof.
Lake Te Anau, Fiordland National Park, New Zealand – 1/4sec at f/19, 35–70mm lens, polarizing filter, tripod, Canon EOS 600

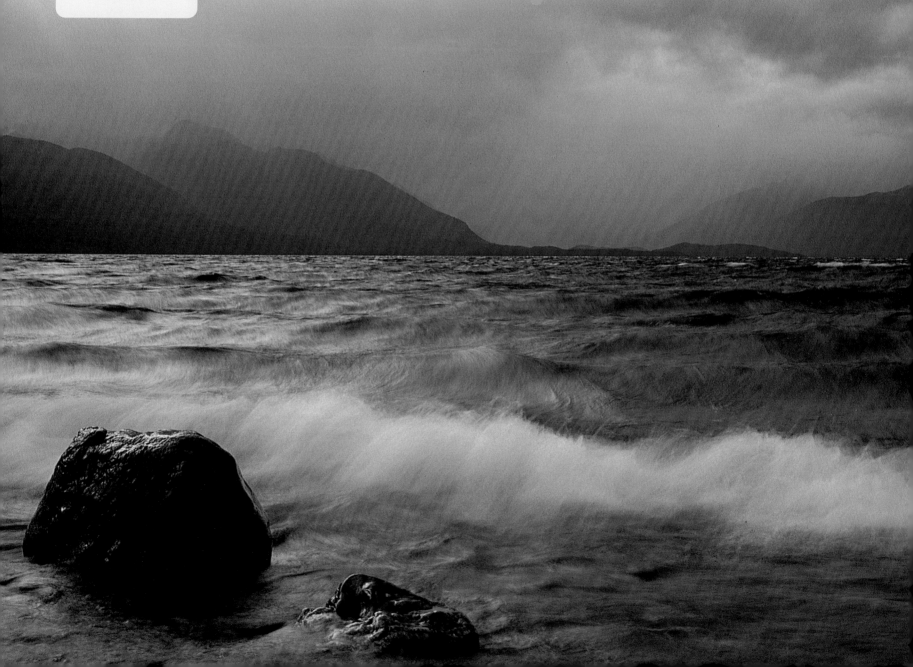

Photographic equipment

Before you can start to consider your camera equipment you have to think about what you are going to carry it in. The ideal choice for a day camera bag is a small rucksack, preferably divided with a dedicated photography area as well as space for general day-to-day use. This will be used for transporting drink, food, first-aid kit, waterproofs, hat, gloves, map and compass – all essential on a day's hiking trip. If you should wish to undertake hikes that last more than one day you will require a far more substantial hiking backpack. The volume of these bags is measured in litres, with an 80 litre model being adequate for most trips. This size backpack will have ample room for all the necessary extra equipment required for an overnight stay, as well as providing space for a more conventionally styled gadget bag that should be located near the top of the backpack for convenient access when hiking.

The choice of camera format is always a tentative issue. The majority of landscape photographers stress that image quality is paramount and that nothing smaller than medium format equipment should be utilized. To a point this is true, but if you consider the essential equipment that a wilderness photographer has to carry to reach or even

The variety of camera equipment available for the wilderness photographer is enormous. However, when choosing equipment, consideration has to be paid towards the space required, weight and versatility of a camera system before the photographer can plan a visit to the wilds.

*The undertaking of overnight trips will dictate the carriage of extra equipment. The choice of a comfortable backpack is as essential as the choice of photographic gear carried. **West MacDonnell National Park, Northern Territory, Australia – 1/8sec at f/19, 24mm lens, polarizing filter, tripod, Canon EOS 300***

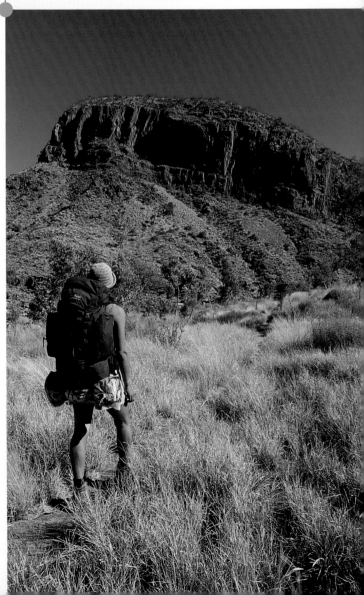

survive a location, then a smaller camera, and therefore a smaller format, has its obvious benefits. The question of image quality is still apparent, but with the advance in the technology behind the new film emulsions on the market, it is possible to capture images with fine grain and good degrees of colour saturation on even the most basic of 35mm equipment. Furthermore, it is possible to have these photographs reproduced in magazines and books or even enlarged to prints sized at 46 x 30cm (18 x 12in), without the viewer noticing any significant lack in quality compared to a similar shot captured on a bigger format. There is also an alternative format to the traditional camera film available to the wilderness photographer in the form of the digital

camera. Although at present the benefits of using digital photography are slight compared to their use in other fields of photography, it can be expected to see their use in the wilderness becoming more common with the advance of the technology. At the moment only the image quality of the more expensive, professional camera models are comparable to 35mm film and are still inferior to the larger formats.

Depending on the model of your camera, you may require an additional handheld light-meter to determine the timed length of exposure for your wilderness compositions. The handheld light-meter offers the photographer a far

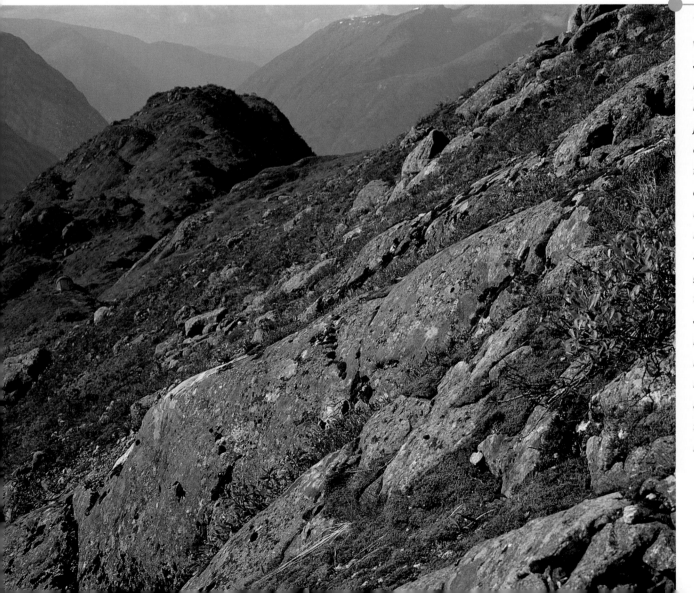

The main consideration when choosing to use 35mm equipment or medium format and larger, is whether you can justify the increased quality of image against the extra weight to be carried. If time is limited, it should also be taken into consideration that 35mm equipment is generally easier, and therefore quicker to use. ***Jostedalsbreen National Park, Sogn Og Fjiordane, Norway – shutter speed not recorded, at f/16, 80mm lens, polarizing filter, tripod, Mamiya M645J***

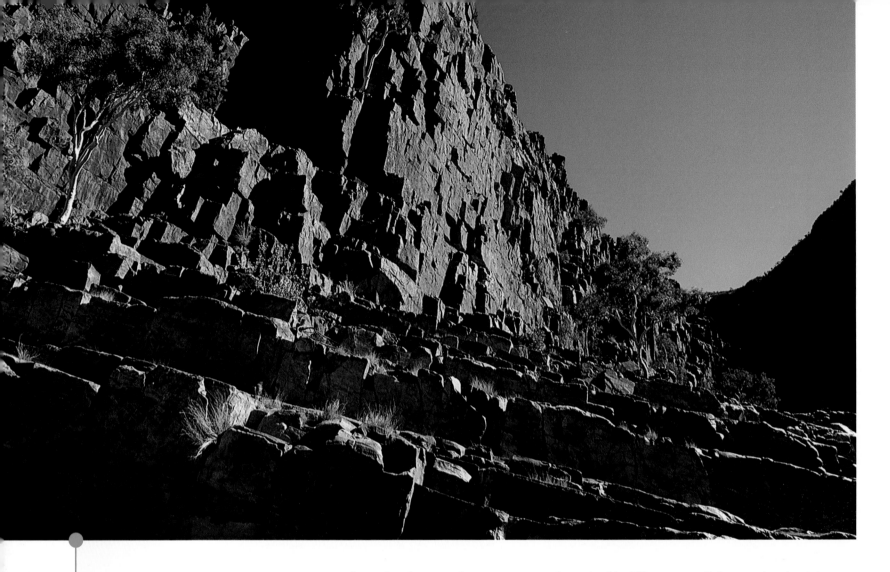

The 24mm wide-angle lens is a useful focal length for the wilderness photographer to carry, although essentially the landscape will dictate when the lens can be used for a successful composition. **Ormiston Gorge, West MacDonnell National Park, Northern Territory, Australia – 1/6sec at f/19, 24mm lens, polarizing filter, tripod, Canon EOS 300**

more accurate means of metering than even the most sophisticated, 'through-the-lens' (TTL) metering system and would be a useful accessory for any wilderness photographer. As ever there are various models available, with the preferred ones offering a spot-metering facility. This kind of meter offers the opportunity to the photographer to obtain numerous readings from different points of a composition, aiding in the final, evaluative decision of exposure.

Gone are the days when the photographer would have to carry a bag full of different prime lenses to anticipate the various focal lengths that may be required for a wilderness composition. The zoom lens has evolved and although the quality is still not as high as a prime, fixed focal length lens,

the noticeable differences are slight, meaning that it is now possible for the 35mm photographer to cover the more required focal lengths with just one or two lenses.

You should be aiming to always carry lenses that cover the following focal lengths (or equivalent if not using the 35mm format): 24mm, 28mm, 35mm, 50mm, 90mm and 200mm. If money and space are a restraint, a good starting lens is a 28–200mm zoom followed by the purchase of a 24mm prime lens at a later date.

Choosing a filter system for your camera can be a complicated business. The choices seem endless with the primary consideration being which type of system to opt for – the traditional screw-on filter or the slot-in holder variety.

With this in mind, there is no other option but to explore the slot-in range of holders and filters. There are a vast array of systems available, covering different sized and varying quality filters at a range of prices. Reassuringly, there are a handful of lower budget versions available which can offer good value for money and high quality results.

When bought new, many modern SLR camera systems include the basic, standard telephoto lens. The focal lengths of these lenses vary, although most cover a range from 35mm to 80mm offering the wilderness photographer flexibility when working in the field. Although not ideal, this lens would suffice as an all in one solution for the photographer on a budget. **Mt Hassell, Stirling Range National Park, Western Australia – 1/6sec at f/19, 35–80mm lens, polarizing filter, tripod, Cannon EOS 300**

You should always ensure that you try out new equipment at a location that is close to home or easy to revisit. In this example, the use of an additional filter coupled with a wide-angle lens has resulted in obvious signs of vignetting within the corners of the final image. With the majority of modern SLR camera viewfinders only showing 90% of the frame, it is often impossible to predict vignetting without a certain degree of trial and error.

TIP
Users of auto-focusing lenses must ensure that they use a circular polarizing filter and not the cheaper linear variety, which will affect the camera's focusing and sometimes even the metering system.

When it comes to choosing a system, the screw-on filter is the easier-to-use option and many a spectacular photograph has been captured using just one screw-on polarizing filter. Every wilderness photographer should always have a polarizing filter in their camera bag.

The screw-on format begins to falter when you start to use more than one filter. Vignetting can occur on images that are captured with the wider focal length lenses. Another disadvantage with the system is that it makes it impossible to use an effective neutral density graduated filter. This filter is vital when using transparency film as it allows the photographer to balance the levels of light across the frame, and should be condsidered an essential item within your camera bag.

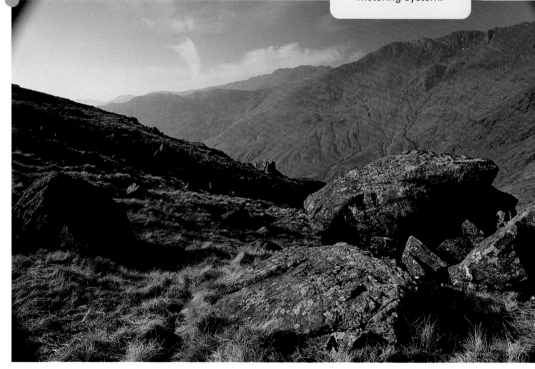

In this image the use of a polarizing filter has led to a greater level of colour saturation in the foliage and sky, as well as helping to eliminate any flare that may be present on the water's surface. The polarizing filter should always be considered an essential accessory to carry. **Fiordland National Park, New Zealand – 1/15sec at f/19, 24mm lens, polarizing filter, tripod, Canon EOS 600**

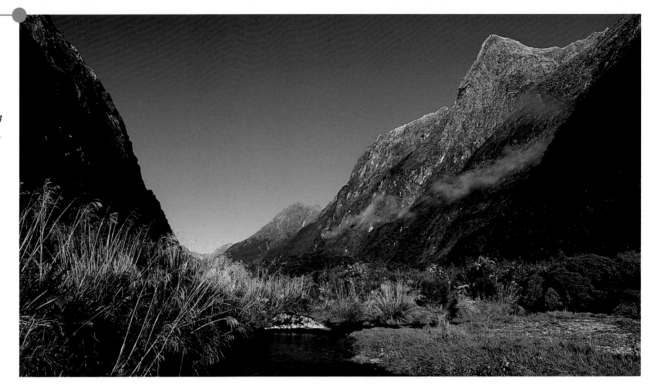

The value of using a high-quality filter is often overlooked but is an important consideration. If a low-quality filter is attached to the front of an optically high standard of lens this will impair its overall performance. As a result your picture quality will decrease and you will find that you obtain the reverse of what you actually set out to achieve – improved photographs. It cannot be stressed enough that it is always best to buy the highest quality filters that your budget allows.

Lastly and undoubtedly the most useful accessory is the tripod. Although this will probably be the heaviest piece of equipment you have to carry, the benefits of using a tripod are substantial. The tripod enables you to utilize longer exposures, essential for low-light photography and a valuable aid for conveying the sense of moving water when photographing waterfalls, streams and rivers. In addition, using one helps to slow down the picture-making process, encouraging you to contemplate your composition with more thought. The photographer should purchase and always carry a good, heavyweight model – an insubstantial tripod will not hold your camera secure under heavy winds or loose terrain. If you wish to avoid back-strain, although at a severely increased cost, it is possible to buy a carbon fibre model that will offer the stability of a heavier model but at a fraction of the weight.

To use a tripod effectively you will need two additional accessories. First, a remote release is essential for triggering the camera's shutter when using a tripod. Failure to use one may result in soft images caused by camera shake from your own hand releasing the shutter. There is an alternative to a remote release by means of using your camera's own self-timing mode, although this method does not allow for critical timing when releasing the shutter. The other essential accessory is a miniature spirit level – preferably hot -shoe mounted if your camera has the facility. This inexpensive piece of gear will ensure that your landscape is always straight, forever removing uneven horizons from your wilderness compositions.

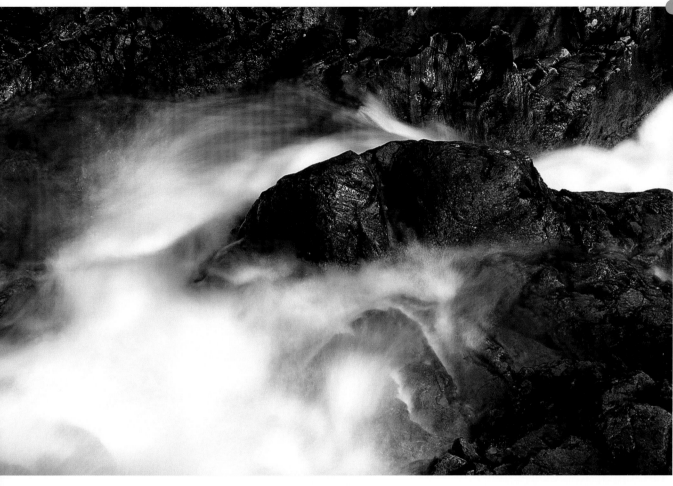

The tripod is a piece of equipment which should be carried whenever possible. It is a valuable compositional aid that allows the photographer to scrutinize the framing of an image before releasing the shutter of the camera. Furthermore, the carriage of a tripod will provide the means to use a long exposure. **Dungeon Ghyl Force, Lake District National Park, England – 1/2sec at f/22, 35–80mm lens, combined 81A and polarizing filter, tripod, Canon EOS 300**

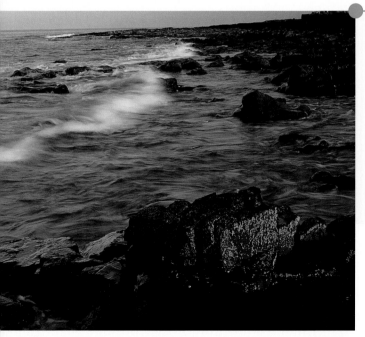

When using medium and larger format equipment, the tripod becomes a necessity as handheld photography is virtually impossible. When photographing areas of coastline, the use of a tripod coupled with a spirit level, will allow the photographer to produce an image with a perfect horizon. **Craster, Northumberland Heritage Coast, England – shutter speed not recorded, at f/16, 80mm lens, polarizing filter, tripod, Mamiya M645J**

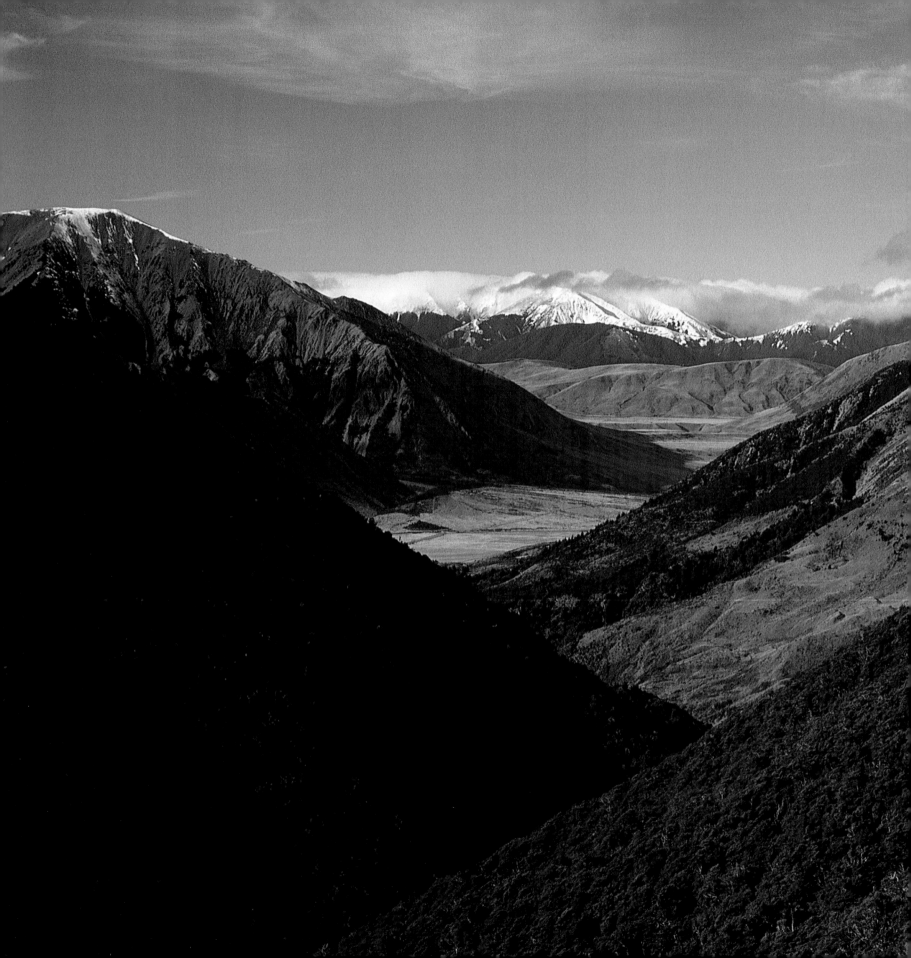

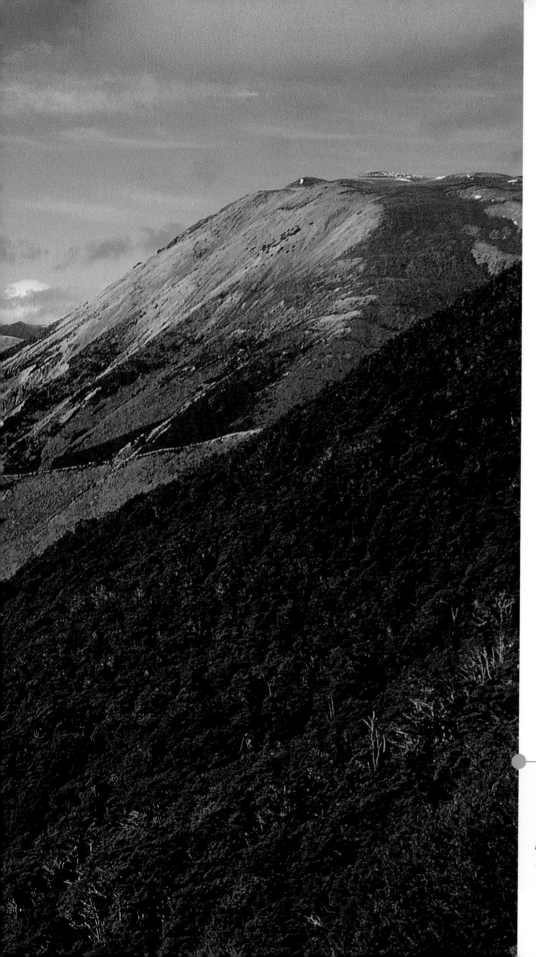

Planning a trip

Certain areas of wilderness require more detailed planning to reach than others, with access and safety being paramount considerations. In addition, irrespective of the location, forward planning will ultimately help you to anticipate what you will actually photograph at a later date. Weather patterns have to be closely monitored before entering wilderness locations as they will provide an idea of what to anticipate as well as indicating the photographic opportunities available.

Craigieburn Forest Park, New Zealand – 1/8 sec at f/19, 35–70mm lens, polarizing filter, tripod, Canon EOS 600

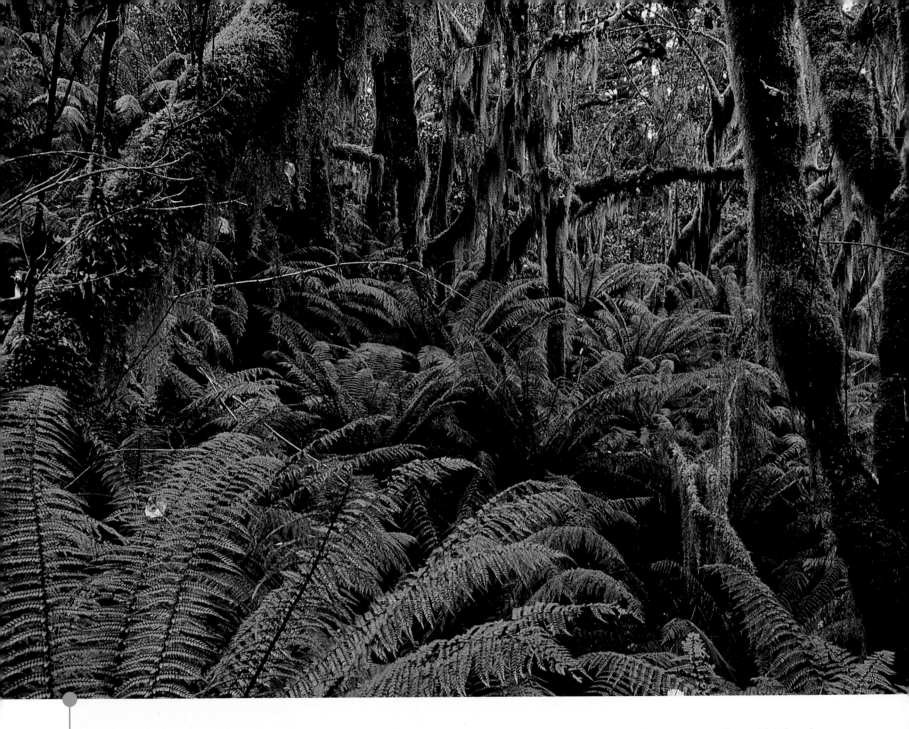

Research before visiting this location informed me that it would be possible to photograph vast tracts of pristine temperate rainforest. This image was captured on the second day of the Milford track, which happened to be a rare, sunny day in Fiordland. As a result, I captured the image after the sun had set, reducing the levels of contrast and eliminating any distracting highlights.

Consequently the spot-metered exposure reading which I took from a mid-tone, green leaf was 30 seconds at f/16. In addition I used a polarizing filter to help enhance the colour saturation within the image. **Rainforest, Fiordland National Park, New Zealand – 30sec at f/16, 24mm lens, polarizing filter, tripod, Canon EOS 600**

Trekking overnight

For obvious reasons overnight trips require the most forward planning, especially when you intend to visit areas that are generally unreachable by a conventional land vehicle. A good example of the amount of forward planning that can be required is a hike that my partner and I undertook in New Zealand's Fiordland National Park during late autumn.

Meals had to be planned for every night spent out in Fiordland, with extra food having to be carried in case of an emergency. Furthermore, the route was located on maps that helped to alert us to any possible hazards, such as the crossing of the Mackinnon Pass, as well as giving me an idea of what would be available to capture photographically. Before we started the walk, the local National Park office was contacted to obtain any essential information regarding the track and its terrain, and was informed of our intentions.

The Milford track is located within a remote area of wilderness found within Fiordland National Park. The only ways to witness the track's sensational landscape are by foot or from the air. Starting from Glade House on the northern end of Lake Te Anau and accessible only by boat, the track stretches 54 kilometres (33.5 miles) following the Clinton river before crossing the Mackinnon Pass and then finally continuing alongside the Arthur river to the picturesque Milford Sound. Here the Milford Sound township and access road back to Te Anau can be reached, but again only by means of a chartered boat. This meant that thorough planning was required before we even considered packing our bags. First we had to decide how long it would take us to walk the track so that we could charter a boat to take us to its start and then charter a separate company to collect us at the other end. We then had to arrange land transport from the boat's drop-off point back to the initial launch point. In addition, it was essential that we hired a cumbersome mountain radio so that we could receive any essential information regarding possible oncoming weather fronts, as well as providing us with a means to call for help should anyone become injured.

The Milford track

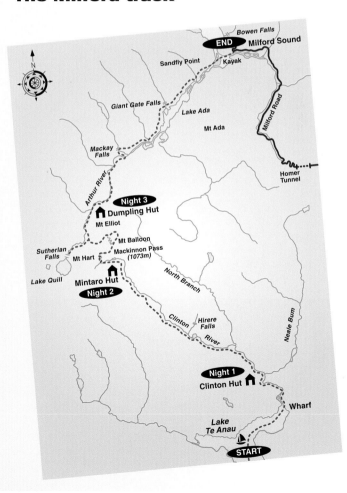

The transport system of the islands of Independent Samoa reminded me why we always allow extra time to reach or leave a destination. Lynette and I planned to visit the island of Savai, where we would spend a week before heading back on the ferry to the island of Upolu, from where we would fly back to the UK. We arrived in the ferry port, where we waited most of the day for a ferry that was suddenly cancelled. The hospitality of the Samoan people is completely unconditional, with numerous strangers offering us a bed for the night. The next day we returned to the port and waited for another five hours before finding out that the ferry was cancelled again! We realized that the Samoan transport system was somewhat unpredictable and decided to hang around the ferry port for a little while longer. Lo and behold, the ferry service was suddenly back on and we were introduced to the Samoan system of queuing for ferry tickets; the entire ferry port (apart from the western visitors who waited patiently at the back) clambering to reach the tiny kiosk!

Access is the primary consideration for many trips into the wilderness during the winter months. The Tongariro track is impassable throughout the months of winter and early spring without the use of an ice axe and crampons, which means that access is available only to the experienced hiker.
Emerald Lakes, Tongariro National Park, New Zealand – at f/19, 24mm lens, polarizing filter, tripod, Canon EOS 600

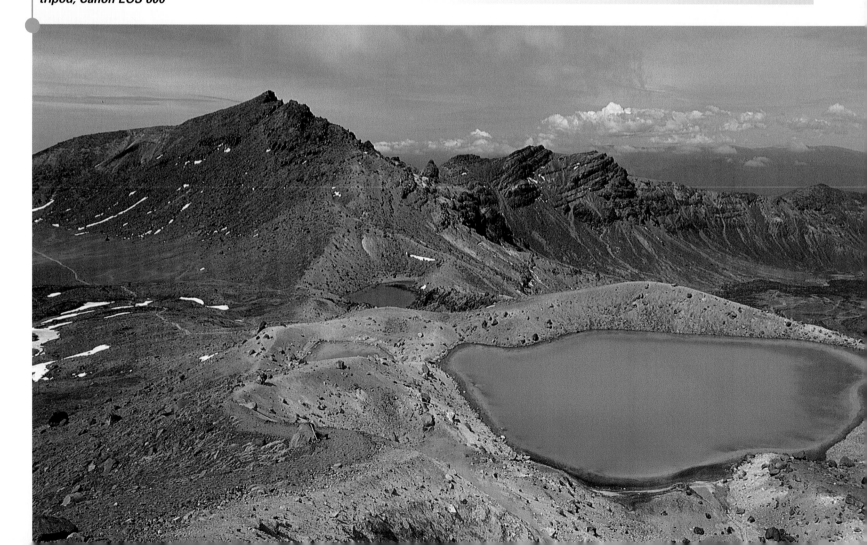

Accessing wilderness areas

Access is normally the first consideration for any trip to the wilderness, be it a day visit or an overnight stay. The season or time of year will also have a huge impact on the planning required, with the likelihood of some areas being inaccessible in the winter months. In addition, there is the possibility of seasonal hazards, such as avalanches, occurring at certain times of the year in some wilderness areas. Always carry out extensive research before visiting a new location. There are many means to actually access an area. Driving is a popular option, but it is also possible to access numerous locations using public transport or local tour operators. However, the lack of flexibility regarding the return trip can become a problem.

Other areas are simply inaccessible by conventional means. Some are surrounded by water or located within wild alpine areas. It is normally quite easy to charter a boat for most water-locked areas especially those that receive large influxes of tourism. However, the wildest areas of the planet are accessible only by foot. Places such as this are considered by some as true wilderness and reaching such locations on foot provides immense satisfaction.

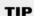

TIP

When driving to wilderness locations for overnight treks, ensure that there is somewhere you can park your vehicle safely overnight.

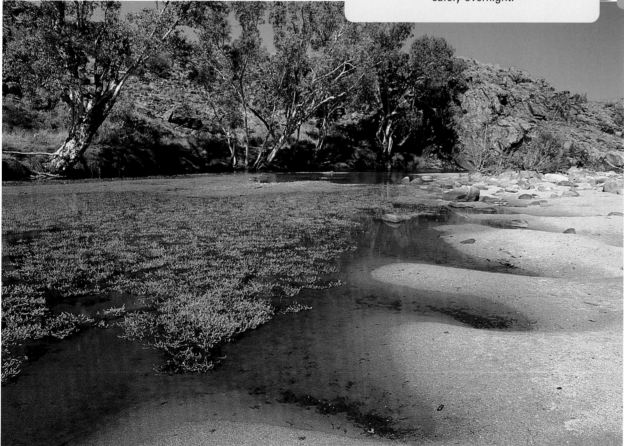

The photographer venturing well off the beaten track must ascertain the location of a reliable water source before embarking on the trip. Studying a map of the area to be visited will help the visitor to locate streams and rivers, although in some areas these may well be only seasonal and in these instances local knowledge must be sought. **West MacDonnell National Park, Northern Territory, Australia – 1/8 sec at f/19, 35–80mm lens, polarizing filter, tripod, Canon EOS 300**

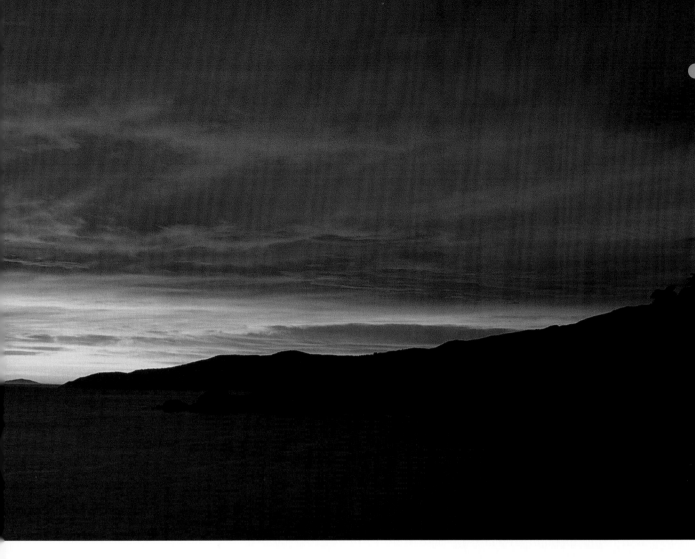

Good forward planning will allow the visitor to photograph locations when the light is most beneficial. It is also a good idea for the visiting photographer to browse through any postcards depicting local scenes and landmarks on sale in gift shops and so on, as it will allow them to contemplate their composition and avoid repeating any over-familiar shots of the area. **Long Harry, Stewart Island, New Zealand – 10sec at f/19, 35–70mm lens, tripod, Canon EOS 600**

SUNSET

Hours P.M.

22 · 21 · 20 · 19 · 18 · 17 · 16 · 15 · 14

60°S · 40°S · 20°S · 0°(Equator) · 20°N · 40°N · 60°N

J F M A M J J A S O N D

SUNRISE

Hours A.M.

10 · 9 · 8 · 7 · 6 · 5 · 4 · 3 · 2

60°N · 40°N · 20°N · 0°(Equator) · 20°S · 40°S · 60°S

J F M A M J J A S O N D

Sunrise and Sunset

By comparing the latitude of any location to be found within 60°N and 60°S with the time of year when you plan to visit, it is possible to ascertain the times of sunrise and sunset.

TIP

To determine coastal patterns
for a certain area, record the high and
low tides for a beach and then
revisit the location the next day.
By evaluating the difference in tide
times it is possible to ascertain the tide
timetable for each subsequent day.
However it should be remembered
that this information would only
be reliable for that area.

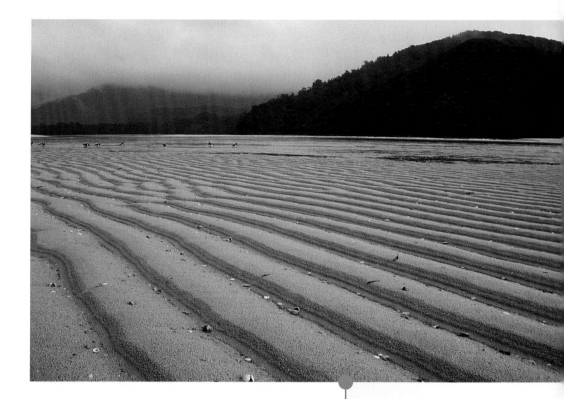

Changing daylight

The time of year will dictate the amount of daylight hours available for the hiking photographer, which will in turn govern the distances that can be covered on foot. As a result, a route which would take two days to undertake in the summer may take four days in the winter. It is obviously important to consider this when planning a trip into the wilderness. A winter trek can be hugely rewarding for the photographer, although it has the disadvantage of the weather patterns being more temperamental.

It is possible to ascertain the sunrise and sunset hours of many countries through the use of a simple graph, helping the photographer to plan a trip into the wilderness that utilizes the daylight hours available. For example, you may be planning to visit an area where no overnight stays are allowed. This would entail a two-way hike that would need to be completed in daylight. If the start location is reached on public transport, you would hope to make your return journey home within the hours of daylight – never plan to

make a return route in the dark. Without the advance knowledge of the hours of light available for a foreign destination, it is impossible to effectively plan a wilderness trip that will maximize your photographic opportunities.

High and low tides

A tide timetable is an essential companion for planning walks along stretches of coastline. A dry and gentle walk at low tide may well become a harder walk involving deep wading at other times of day, in turn reducing the distances covered. It is possible to buy tide-tables at most locations that you visit or, in the event of no such table being published, the same information can be obtained by asking local fishermen or watching an area's tidal routine yourself. A coastal stretch found just a few miles up or down from the original beach will have differing times although your predictions will be useful as a rough guide. If you wish to refer to these times when planning a trip for foreign destinations, the use of a search engine on the internet will normally provide the results you require.

*The photographer wishing to undertake hikes along coastal routes should always refer to a local tide timetable when planning a trip, as it is quite possible for some routes to become totally impassable at high tide, such as the Awaroa estuary on the Able Tasman track in New Zealand. **Able Tasman National Park, New Zealand – 1/10 sec at f/19, 35–70mm lens, 81b filter, tripod***

Planning a route

Understandably, one of the most essential pieces of equipment for the wilderness photographer is the map. Without it you cannot effectively plan a trip or safely navigate the route when actually visiting the location. Maps are an excellent way to anticipate the prominent features of any landscape that you intend to visit. Topographical maps will also allow you to pre-visualize the grandeur of a landmass and are especially useful for planning alpine visits. By studying a good quality map it is also possible to predict what features of a landmass will be illuminated by the rays of the rising or setting sun.

To determine this it should be remembered that the sun will rise from an east position and set towards the west. The height of the features of a landscape must be noted to anticipate how much of them will be illuminated.

By scrutinizing a good quality topographical map, it is often possible to ascertain the location of any geographical oddities in the area. Using a good map will also help the photographer to determine at what time of day the location will benefit from being bathed in good illuminating light.

Pancake Rocks, Punakaika, New Zealand – 1/30 sec at f/22, 35–70mm lens, tripod, Canon EOS 600

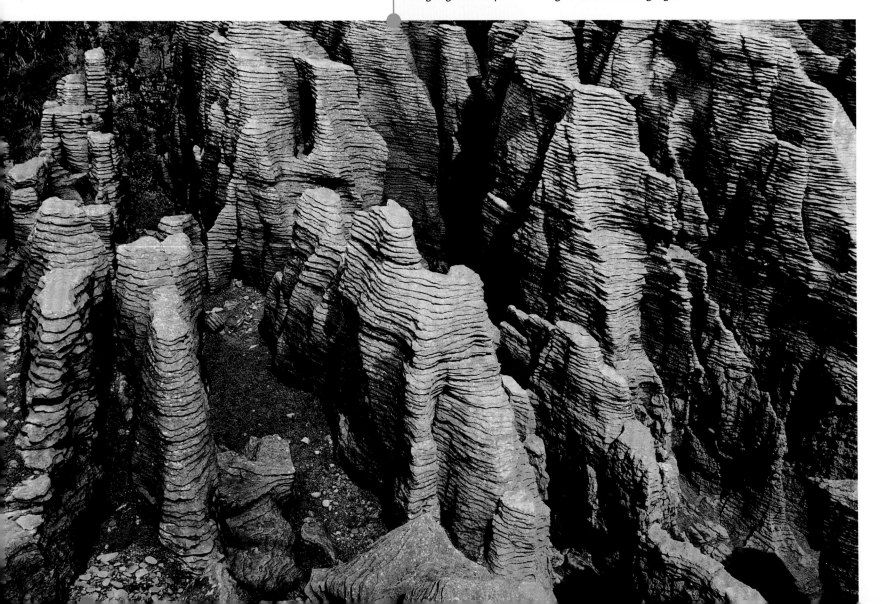

Although not necessary in most parts of the world, visiting certain areas of wilderness will require that the photographer obtains a permit for still photography before capturing any images. This often only applies to the 'professional' working with a tripod. The Uluru-Kata Tjuta National Park in Australia is one such place where permits must be obtained before capturing this otherwise forbidden landscape. **The Olgas, Northern Territory, Australia – 1/8sec at f/19, 35–80mm lens, polarizing filter, tripod, Canon EOS 300**

TIP

Always ensure others know of your planned route before entering the wilderness. Important information to be recorded includes the intended route and expected date of return. It is also a good idea to agree on an 'emergency date' when the local search and rescue authorities should be notified.

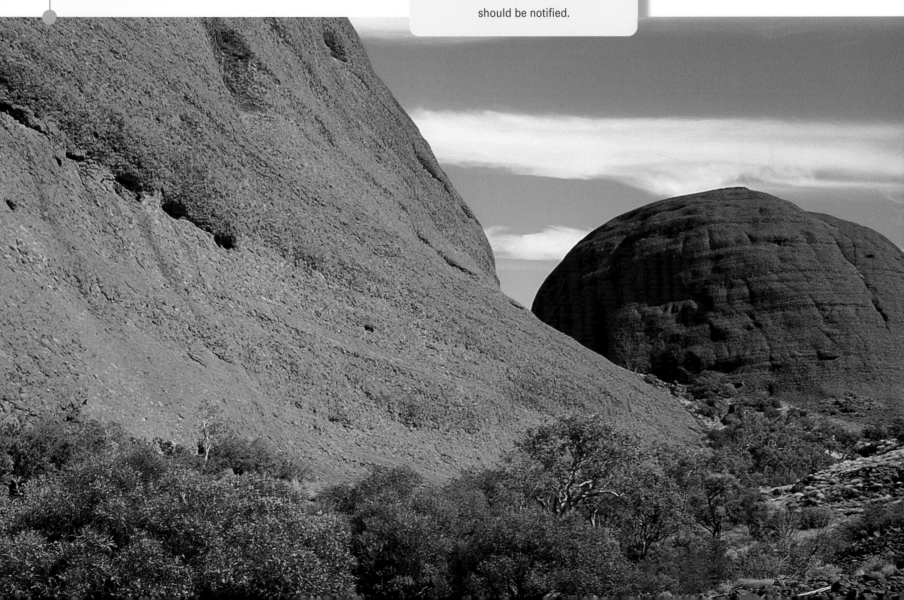

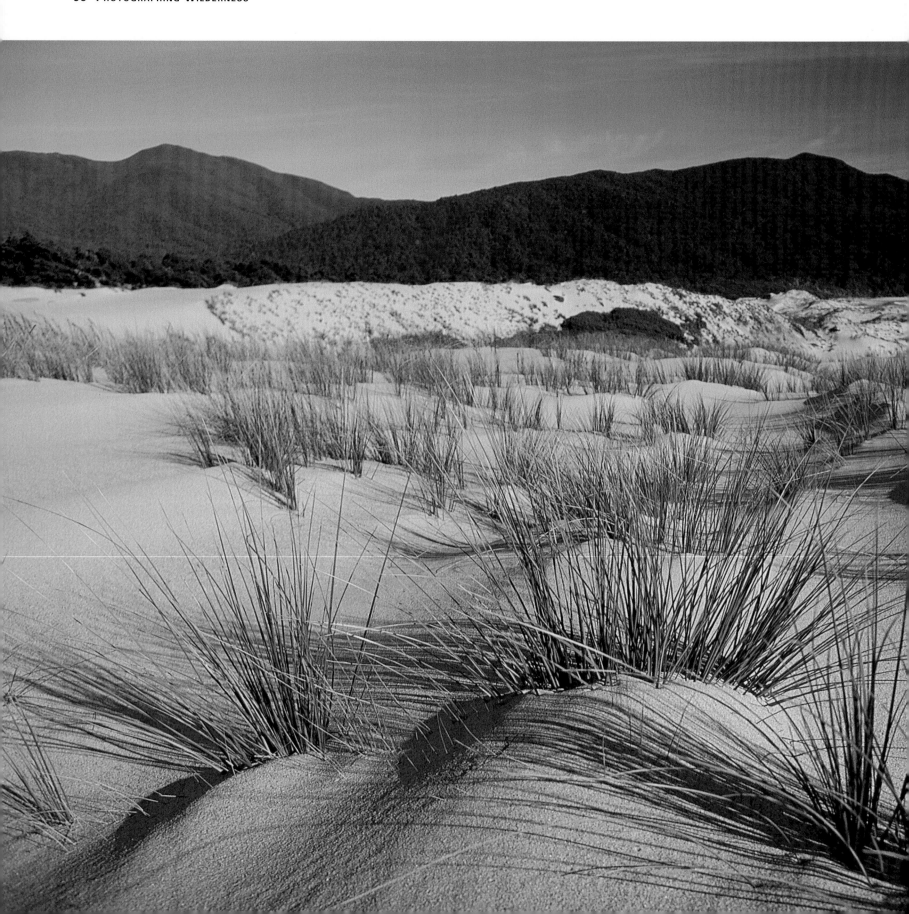

Last, but by no means least, you must always be sure that
you inform someone of your intended route before entering
the wilderness. For overnight hikes this would mean
notifying them of the route, locations of intended
overnight stays and the dates for each stage of the trip.
You must then plan to contact this person when you finally
finish the trip so that in the event of you not doing so they
will contact the emergency services with your intinerary.
Considering the amount of responsibility required on the
part of your nominee, you must ensure that you only ask
someone you consider both reliable and trustworthy.
Many authorities throughout the world offer a system
where a book is signed when entering and leaving
popular trails.

It is evident that some locations will require more planning
than others, and that overnight stays will generally require
further planning still. However, a high amount of forward
planning will greatly improve your time spent actually
photographing a location, as well as helping to ensure your
own personal safety when visiting the wilderness.

*Smoky Beach, Stewart
Island, New Zealand.*
**1/125sec at f/5.6, 24mm
lens, polarizing filter,
tripod, Canon EOS 600**

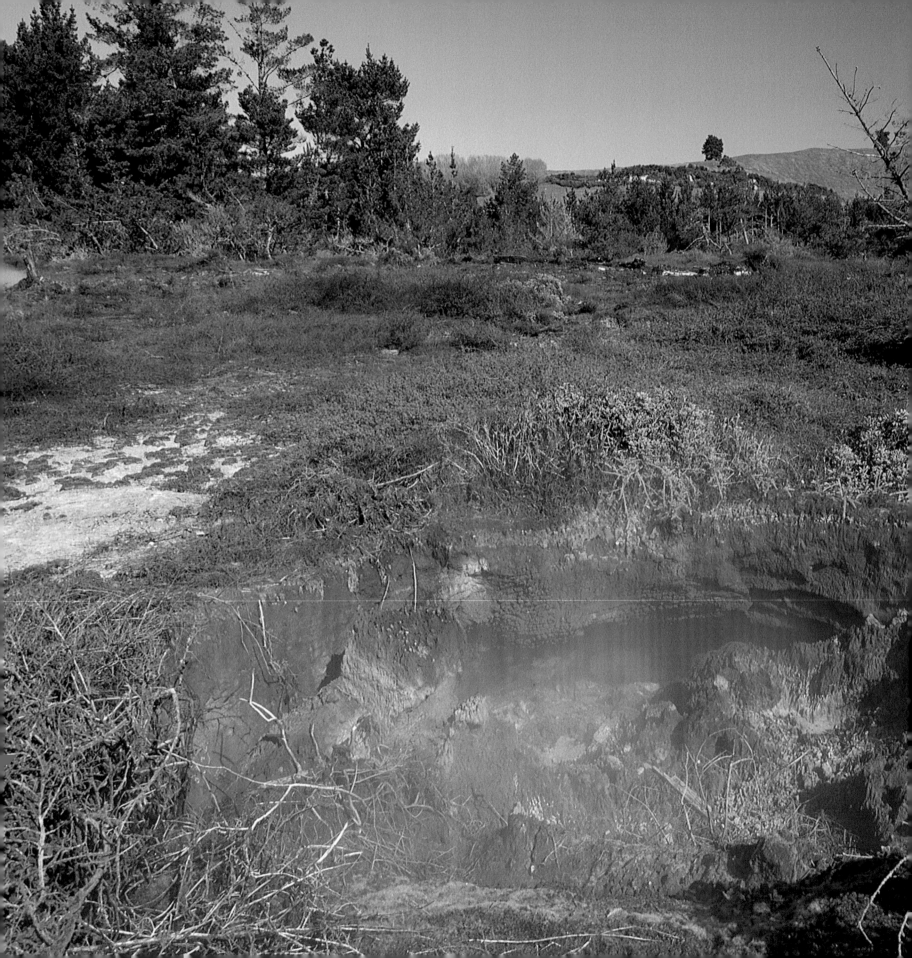

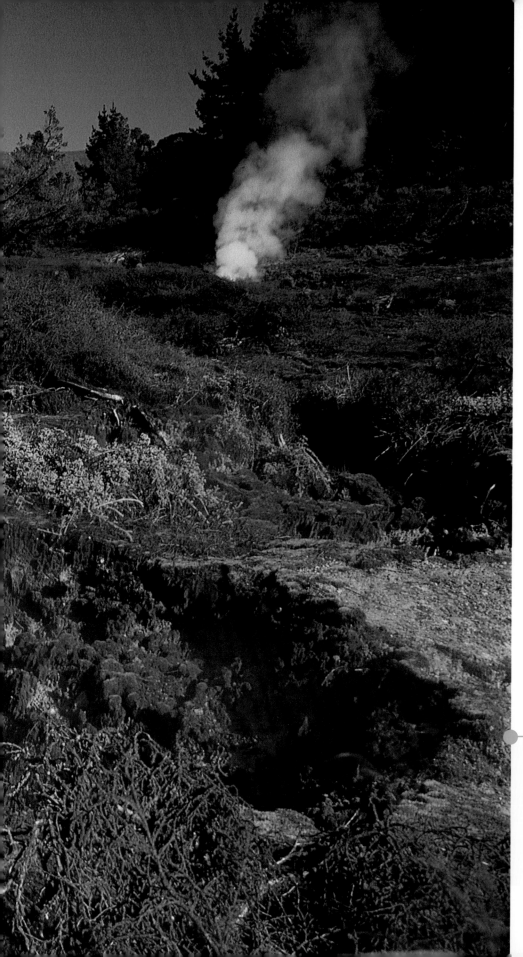

Surviving the wilderness

The wilderness photographer working in the field should always be prepared for any unexpected safety issues, and although most trips will be uneventful, there is always a risk that the unthinkable could happen. The only way to deal with these situations is to know how to recognize any warning signs and when and how to make what could become a life-saving decision.

Craters of the Moon
Scenic Reserve, Wairakei,
New Zealand – 1/8sec at
f/19, 24mm lens,
polarizing filter, tripod,
Canon EOS 600

Not only should a first-aid kit be carried for any trip into the wilderness, but also the knowledge of how to implement the basic first-aid techniques. If the photographer is not aware of these possible life-saving techniques, a pocket first-aid guide should also be carried. **Jostedalsbreen National Park, Sogn Og Fjiordane, Norway – 1/8sec at f/16, 80mm lens, polarizing filter, tripod, Mamiya M645J 300**

First-aid kit

Foresight is the key. By carrying a small first-aid kit the photographer will be prepared for many different situations. From a mild headache caused by the glare of the sun to the treatment of a potentially fatal snake bite, the basic first-aid kit offers the carrier the opportunity to deal both promptly and efficiently with a condition whilst considering if external help is going to be required.

TIP

Adapt your medical kit for yourself and your walking companions and be sure to check whether a member of the party has a history of adverse allergic reactions or suffers from a medical condition such as epilepsy.

Drinking water

On many overnight trips, and in some areas on day hikes, the photographer will be required to obtain a reliable source of drinking water. This will not prove to be a problem in the majority of alpine areas where the many flowing streams and waterfalls will provide a supply of clean and enjoyable drinking water, however there are many wilderness locations in which water is not so easy to come by. Avoid collecting water that is calm and stagnant, as this may have little oxygen allowing miniscule life forms to thrive and prove a possible hazard to the consumer, as well as giving the water an unpleasant taste.

Unfortunately it is normally the things that you cannot see that will cause you the most harm. The only way to avoid this is by purifying any drinking water that you collect. The simplest way of purifying water is by boiling it. Vigorously boiling the water for five minutes should kill all the undesirable foreign bodies although at higher altitudes, where water boils at a lower temperature, this is less likely to be effective, and you will need to use a different technique.

It is possible to buy water filters but used alone they will not remove all dangerous organisms. The only way to ensure safe drinking water is through chemical purification. The addition of chlorine tablets to the collected water will kill most pathogens but not all. One such pathogen that is unsusceptible to the use of chlorine is the one that causes giardia. This is a particularly unpleasant intestinal disorder that can appear many weeks after infected water has been consumed. The symptoms of giardia include stomach cramps, nausea, bloated stomach, diarrhoea and gas. This condition can occur periodically for many weeks with treatment being the only cure. The use of iodine (in tablet form) is the only way to effectively eliminate the presence of such organisms from your drinking source, although care does have to be taken as too much iodine added to the water can be harmful.

Hypothermia

Hypothermia is a serious condition that can occur in numerous situations although photographers working in wet and windy conditions are most at risk from it. If left untreated it can prove fatal.

The way to avoid a drop in the body's core temperature, the scenario that causes hypothermia, is to wear suitable clothing for the situation and to seek shelter if faced with extreme weather. Wet clothes contribute to hypothermia; the wearing of good waterproofs will eliminate this factor. Wet clothes become particularly dangerous when combined with strong winds, with any drop in the body's temperature being accelarated. Again, good windproof clothing will help, as will hats and gloves, but the real key is to know when to shelter.

*Even though deserts can be the hottest of places during the hours of sunlight, they can prove to be bitterly cold throughout the night. As the wilderness photographer often works before the first rays of sunlight, the carriage of cold weather clothing is imperative for any unexpected weather conditions. **The Pinnacles, Nambung National Park, Western Australia – 2sec at f/19, 35–80mm lens, tripod, Canon EOS 300***

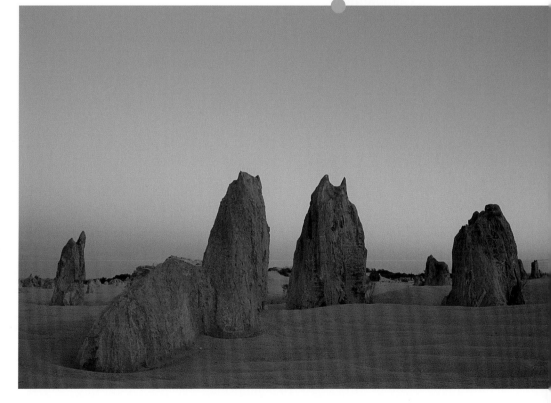

It is the combination of cold and wet, especially in alpine areas, that makes hypothermia a very serious danger to the hiking photographer. The onset of hypothermia can be incredibly quick, although it can take days to fully recover, and in some cases it does result in death. **Mount Cook, Mount Cook National Park, New Zealand – 1/2sec at f/22, 24mm lens, polarizing filter, tripod, Canon EOS 600**

Hypothermia can be recognized by, amongst other symptoms, exhaustion, numb skin, slurred speech, shivering, dizzy spells, lethargy and irrational behaviour. Mild hypothermia can be addressed by finding nearby shelter from the wind and rain and to then replace most of the patient's wet clothes with dry ones. The patient should drink warm, sweet liquids, although not alcohol, and eat easily digestible, high-energy food.

Severe hypothermia is a more serious condition to treat. If the patient is unable to walk or stand you should not remove any clothing, but place two large plastic bags over them, one covering the feet to waist and the other (with a hole for the head) covering the shoulders to waist. If possible, the patient should then have a sleeping bag placed around them and then another waterproof layer. In this kind of situation a tent could be a real lifesaver, providing shelter to the patient and all members of the party who are also at risk from hypothermia. The treatment of hypothermia can take from one to several days for complete recovery.

Bites and stings

One of the most important considerations for pre-departure planning is to know what native flora and fauna you should avoid when visiting an unfamiliar area, as well as knowing what steps to take should you encounter any of the more unpleasant wildlife.

Leeches are not life threatening but they can be very unpleasant. My first experience of leeches was on a visit to the world heritage rainforests of the Australian State of Queensland, in particular a hike to a majestic waterfall that had been recommended to me. It had rained heavily for a couple of days but had cleared the morning we set off on our hike into the jungle. It did not take long for us to realize that the floor was literally moving, towards us! We were under attack from leeches; every time we stopped several leeches would be on our boots. Even as we walked we would notice leeches clinging to bushes and trees waiting to ambush any unaware bush-walker. When we did finally reach the waterfall I considered setting my tripod up and capturing an image, although the legion of bloodsuckers heading towards me quickly made up my mind. This was definitely a case of the one that got away – luckily it was me!

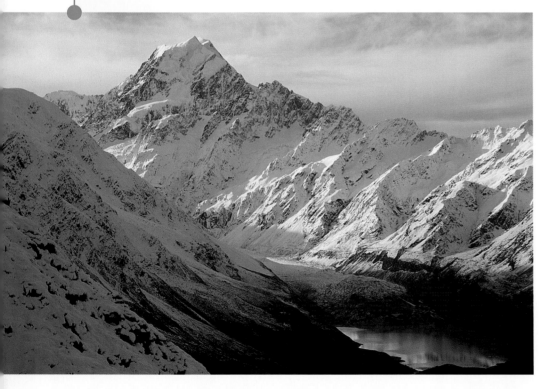

Mosquitoes, a common blood-sucking insect, do spread unpleasant diseases such as malaria in some countries. The key is to avoid being bitten. Even in hot climates, the visiting photographer should cover up and apply a strong insect repellent to any areas of skin that remain exposed. The most effective insect repellents contain a high concentration of the chemical Deet (n,n-diethylmetatoluamide). It should be noted that although Deet is a highly effective repellent, it will also break down any plastic, rubber and synthetic material it comes into contact with, thus care must be taken when using any camera equipment after administrating repellent containing Deet.

TIPS

As an alternative to using tweezers to remove a tick, smother it in Vaseline. This will suffocate the tick and it will fall away after a few hours.

The problem with the smaller, undesirable creatures is that their presence will often go unnoticed until you find them when you are least expecting them. The image I composed here resulted in my body being covered from head to toe in Kangaroo Ticks! My partner was assigned the unpleasant task of removing every one of my unwanted guests using a pair of tweezers. Although ticks are not dangerous if dealt with quickly, they can often spread disease and prolonged exposure to the skin can result in infection. **Grass Tree, Yalgorup National Park, Western Australia – 1/15sec at f/19, 35–80mm lens, polarizing filter, tripod, Canon EOS 300**

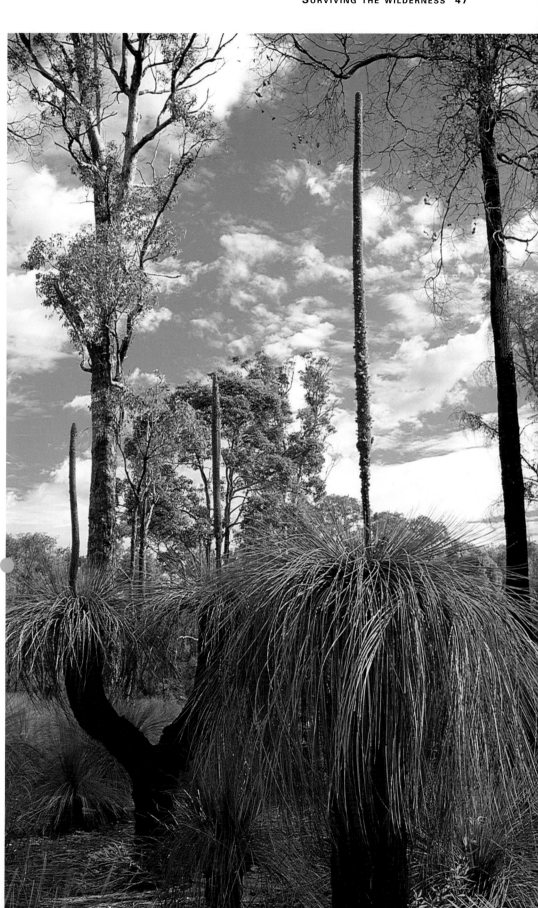

The golden rule for surviving the wilderness is to know your own limitations. Err on the side of safety and never take a risk – no matter how calculated. You might not realize that you are potentially endangering your own life together with the lives of your accompanying party and also of the search and rescue party that may, in a worst-case scenario, have to come to your aid. No photograph is worth this price.
Hancock Gorge, Karajini National Park, Western Australia – 3sec at f/19, 35–80mm lens, polarizing filter, tripod, Canon EOS 300

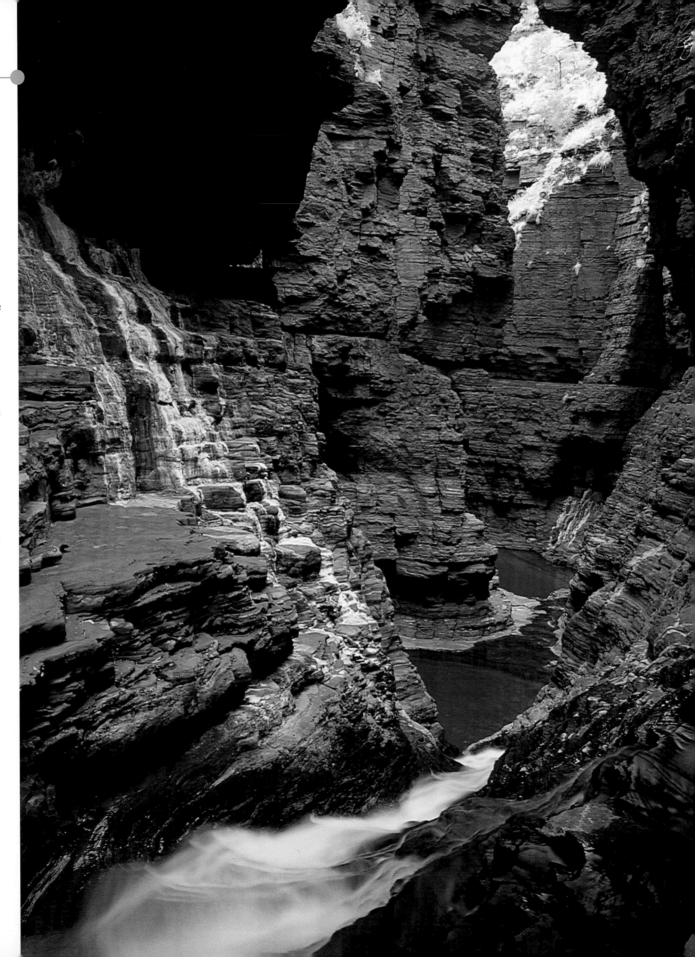

However, not all blood-sucking insects are airborne, and many will attack from the ground. Ticks are one such example, and although they will prove to be of no threat if removed from the body, if left they will excrete a toxin that in the worst instances can cause paralysis and possible death. In addition, they can spread disease. The photographer must always check their body for small lumps after walking in tick-infested areas. If a tick is found, it can be removed by using a pair of tweezers to press down around the head, before very carefully holding the head and gently pulling upwards. The body of the tick should not be pulled with the tweezers, as the contents of the insect's gut could be pushed through its mouth into the victim's skin, leading to the possibility of infection.

Snakes and spiders are probably the most infamous hazard for the working photographer. However, there is only a small minority which can be considered dangerous and they will not normally attack humans unless provoked.

In the event of a bite from either a snake or spider, the victim or companion should try to ascertain the species of the animal. This is essential for the correct antivenin to be administered when the victim finally reaches medical assistance. By identifying the animal, it is also possible to confirm whether the bite is potentially harmful.

The victim must remain calm as stress will increase the spread of the venom by increasing the flow of the blood, as well as endeavouring to keep the position of the wounded limb below the level of the heart. Next, all jewellery worn around the bite must be removed and footwear and clothing loosened if necessary – this is due to the likelihood of extreme swelling of the infected limb. Now a light constricting bandage should be wrapped directly above and below the bite, leaving a space of approximately 5cm (2in) either side of the wound. Then if possible a splint should be attached to immobilize the limb. Meanwhile, another member of the party should attempt to seek out medical assistance.

The most effective treatment for snake and spider bites, or indeed bites and stings from any other creatures, is to avoid the animal in the first place, and to take the necessary precautions should a chance encounter occur. The wearing of correct clothing will offer protection, and the employment of common sense is imperative.

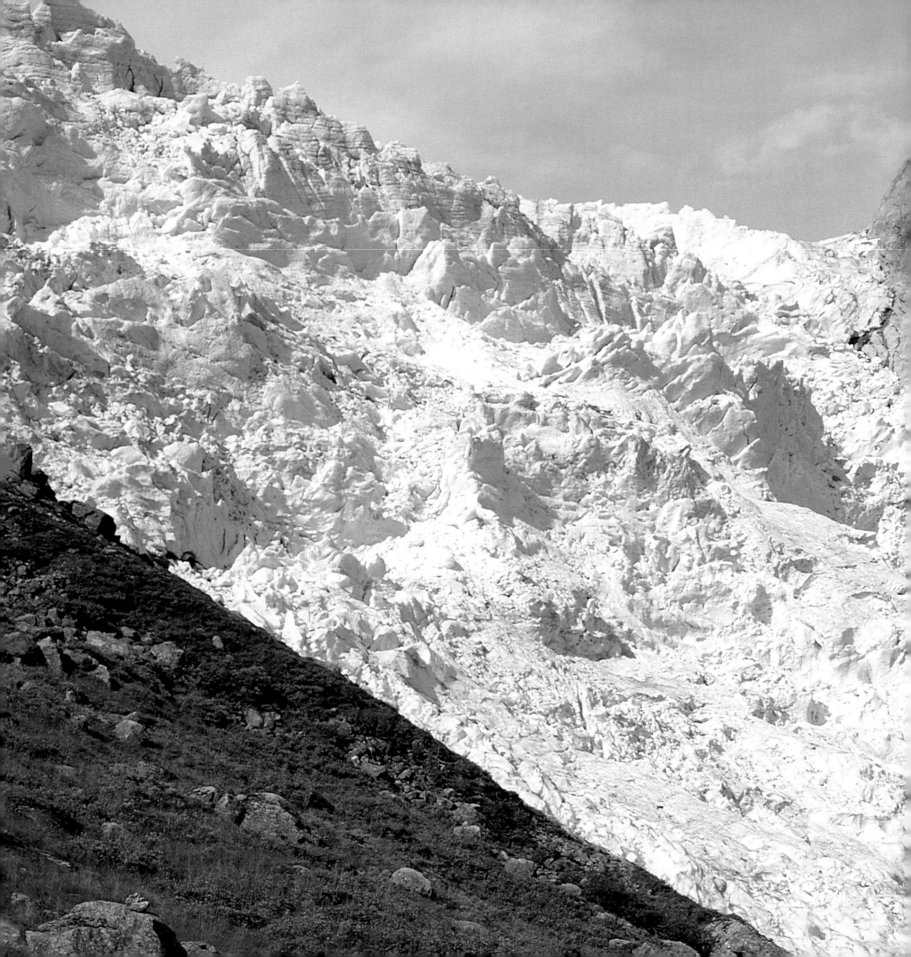

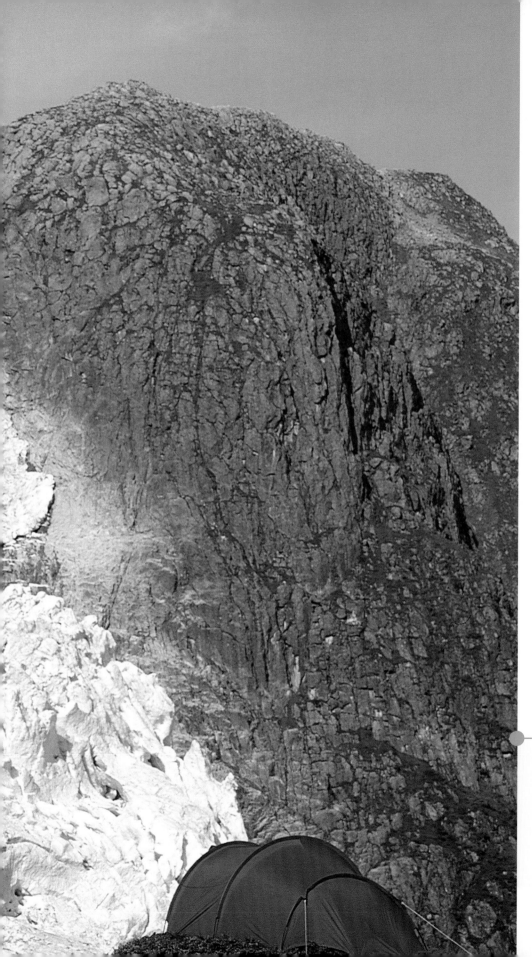

A night under the stars

A night passed in the wilderness can offer a remarkable experience that will remain with you forever. In addition, it will allow you to photograph a location long before the arrival of any day hikers and in an early morning light that is softer and generally preferable for wilderness photography. A night spent under the stars will offer many different opportunities – imagine photographing a spectacular mountain landscape just a few moments after first opening your eyes and leaving your tent. This should be a regular event for the photographer that wishes to fully immerse themselves in the surrounding wilderness.

Jostedalsbreen National Park, Sogn Og Fjiordane, Norway – 1/8sec, at f/16, 80mm lens, polarizing and 81B filter, tripod, Mamiya M645J

This image was captured from one of the most unusual places I have spent a night. We negotiated with a local tribe to pitch our tent on a platform located near the top of a stately banyan tree – high above the rainforest canopy. The surrounding rainforest had suffered serious damage during cyclones in 1990 and 1991 but this tree had remained unscathed. Experiences like this will not only benefit your photography but also your view of the world.
Falealupo Rainforest, Savai'i, Independent Samoa – 1sec at f/22, 35–70mm lens, tripod, Canon EOS 600

Equipment

There is a disadvantage to spending a night in the wilds in that the additional time spent there will require more equipment to be carried. Just one night passed in the wilderness will effectively double the amount of weight you have to carry. Apart from food, you will need to carry extra clothes (in case you should get wet), sleeping bag and roll mat (essential for a comfortable night's sleep), gas stove and cooking utensils (warm food and drink is imperative when spending a night outdoors, especially in alpine areas), water purification tablets (for sterilization of any collected drinking water), a means of light (hand torch or better still, a head torch which allows use of both hands in the dark) and, for visits to pristine areas, a lightweight but sturdy tent. This list of equipment should be considered the bare minimum for a night's wild camping.

It will also be essential that you remove any rubbish that you may generate on your trip. You must never leave or bury discarded items or packaging. As ever you must respect the environment as well as strive to keep intact the unspoilt vista for future visitors to the area.

It should also be remembered that if you are hiking in a hot and arid climate you will probably have to carry all of your drinking water, with most adults requiring a minimum of four to six litres a day. Considering that water is generally required for cooking as well as washing, you should always overestimate the amount of water that you carry unless you are certain that a reliable water source is available. It is always a good idea to seek out local knowledge with regards to available water supplies when visiting an unfamiliar location.

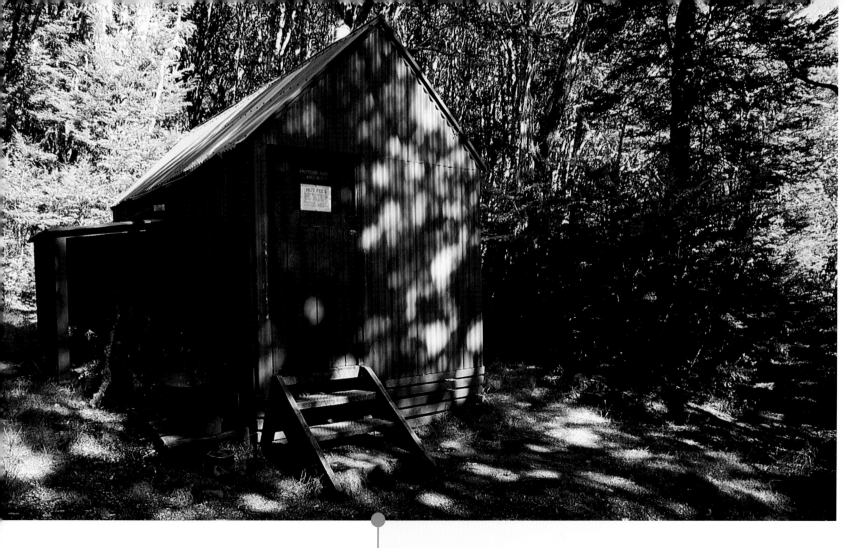

Camping huts

Luckily, in some parts of the world there are a variety of accommodation options available for use on overnight trips, allowing you to leave the tent at home and therefore reduce the weight of your backpack. New Zealand is undoubtedly one of the most famous of these countries, with an impressive array of back-country huts covering the entire mainland and many of the fringing islands. However, a visitor to these huts should not expect a luxurious affair. They are designed for those used to the great outdoors, allowing the locals to enjoy the wilderness areas of their own spectacular country.

This cosy building is one of a few huts situated on the Cass-Lagoon Saddle track. New Zealand has an extensive network of hiking tracks, almost covering the length and breadth of the country. This is coupled with an excellent back-country hut system, providing shelter and heat on most overnight walks and so making the New Zealand wilderness accessible to anyone of average fitness. Some of the tracks have been designated as 'great walks', which helps to control human traffic and the subsequent erosion to the landscape, as well as guaranteeing that a bed will be available at the end of your hard day's walking. This is enforced by means of a booking system at the local Department of Conservation office. The only other requirement is common sense and a desire to escape from civilization and to see the 'real' New Zealand. **Cass-Saddle Hut, Craigieburn Forest Park, New Zealand – 11⁄2sec at f/19, 24mm lens, polarizing filter, tripod, Canon EOS 600**

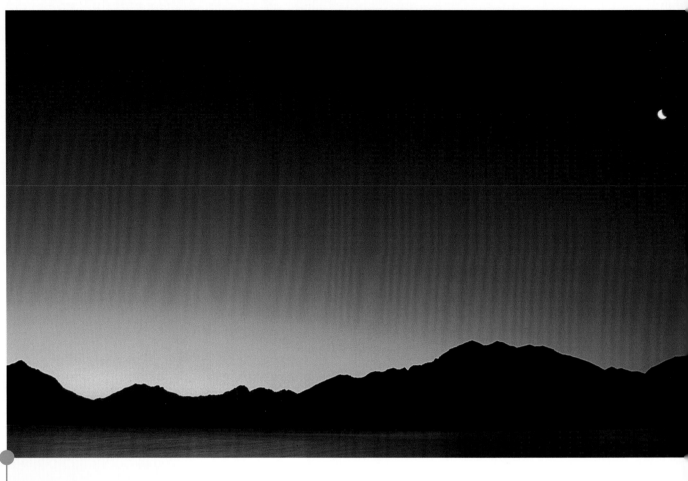

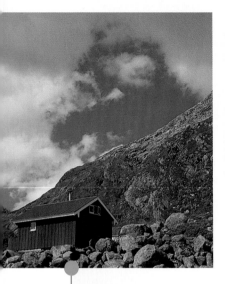

Flatbrehytta Hut, at an altitude of 1000m (3280ft), provides shelter to the many hikers, cross-country skiers and even the occasional photographer visiting the park! This kind of mountain hut makes the Norwegian wilderness even more accessible to the photographer. It means that it is possible to visit these wild areas without a tent, which helps to reduce the weight of what can often be a heavy backpack.
Jostedalsbreen National Park, Sogn Og Fjiordane, Norway – 1/8sec, at f/16, 80mm lens, polarizing and 81B filter, tripod, Mamiya M645J

A night spent under the stars offers excellent opportunities to be near wild locations when the light is more preferable. I captured this image whilst camping at a basic, lakeside campsite. Light levels were very low, which made composing the image a real problem. I employed a hot-shoe mounted spirit level to ensure that the horizon was perfectly horizontal and took an evaluative through-the-lens exposure reading. Additionally, I bracketed the exposure 1 f-stop either side to ensure that I returned with a successful image.
Lake Te Anau, Fiordland National Park, New Zealand – 30sec at f/16, 35–70mm lens, tripod, Canon EOS 600

Many other countries have similar huts although they tend to be more geared towards mountaineers or hunters, although this should not deter the wilderness photographer from using them. Nevertheless, wild camping is probably the best way to enjoy a warm and dry night under the stars without feeling a sense of detachment from the surrounding wilderness. Carrying your own tent is something like the tortoise carrying a shell – home is where you make it. If you find a location that you would like to photograph and if your timetable allows, it is possible to pitch your tent and to wait for the best illuminating light. However, probably the most important argument for carrying a tent is that if the weather should unexpectedly take a turn for the worse or a member of you party should fall ill or receive an injury, then you will have shelter, which could ultimately be the key to avoiding hypothermia and therefore saving a life.

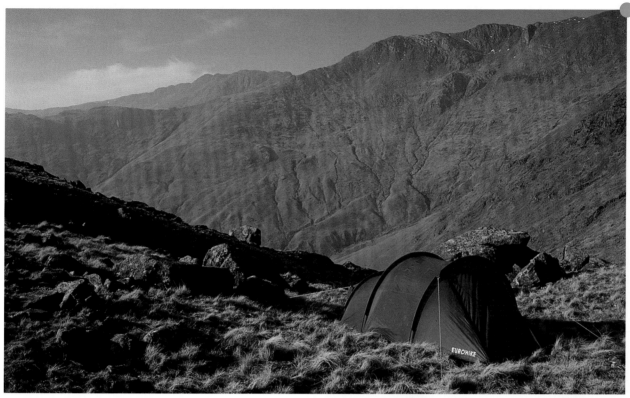

Wild camping is arguably one of the most enjoyable ways to spend a night in the wilderness. Camping overnight allows the photographer to explore a location, enabling you to photograph from various viewpoints over a period of time. **Martcrag Moor, Lake District National Park, England – 1/4sec at f/19, 35–80mm lens, combined 81A and polarizing filter, tripod, Canon EOS 300**

Where to camp?

When spending a night under the stars, you should carefully consider where you actually pitch your tent. If camping in high altitude areas try to position the tent in a location that is sheltered from the oncoming wind. Another technique, that can also be useful when you find yourself camping on any sandy terrain, is to try and locate any heavy but moveable rocks that can then be placed on the tent pegs that are attached to guy ropes. This will help to further secure the pegs and tent, offering more protection in the event of a storm.

You will need to consider a suitable location for a toilet. It is important that any hole dug is at least 50m (164ft) away from any water course. This is essential so as to not pollute any available drinking water – not just for you but also for other humans and any water-dependant wildlife. You should also remember not to wash dishes or use soap or detergent in a natural body of water.

TIP

Even if weather seems clement when you pitch your tent, it is wise to select your location and secure the tent with the worst in mind.

TIP

If you should plan to spend a night pitched by water you must ensure that you consider the possibility of flash flooding which can occur both during and after heavy rains. If possible avoid camping on any flat terrain surrounding the water, choosing an elevated pitch instead.

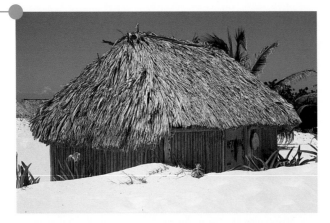

Tropical coastlines in developing countries often offer little opportunity for secure wild camping. However, other options are available for overnight stays on less remote stretches of coastline, including huts, hammocks and beach fales (traditional Samoan huts), offering the photographer the chance to photograph beautiful coastal scenery without including day visitors.
Beach Hut, Tulum, Mexico – shutter speed and aperture not recorded, 50mm lens, Olympus OM10, handheld. Manase Beach and Fales, Savai'i, Independent Samoa – 1/10sec at f/19, 24mm lens, polarizing filter, tripod, Canon EOS 600

Surviving an unplanned night

Not all nights spent in the wilderness are planned events. Some can be the consequence of an unexpected chain of events, for example poor weather and visibility or the photographer simply getting lost. Because of this possibility you should always carry a simple survival bag. This can take the form of a waterproof pack-liner or a more sophisticated crumple sack, which is manufactured with seemingly space-age materials. In the event of an unplanned night you should try to find natural cover, for example from a rock or tree, and then climb into the sack wearing all the clothes you have with you. Remember that even the hottest of countries can be bitterly cold at night.

If you should find yourself waylaid in woodland there is another innovative option available for a night's shelter. Using twine and fallen wood, it is possible to construct a simple but surprisingly effective shelter. Select four large fallen branches of similar lengths and tie them in pairs so that you have two 'A' frames of a similar size. Secure the joined tops of the 'A's to either end of one long branch. Select smaller branches and lean and weave them onto your main frame, then find large dry leaves and drop them from above onto the shelter. By dropping the leaves from above, they will fall and naturally catch on the shelter's frame forming an effective insulating and waterproof layer. This kind of shelter will not offer the greatest night's sleep but when used with a survival bag will provide a certain degree of protection from the elements.

If you visit Australia you will probably find that the local bush-walkers have a simpler approach to spending a night outdoors. They are known to dispense with using tents, huts, or even simple shelters, instead relying on the uncomplicated swag bag. Resembling a sleeping bag combined with a roll mat, the brave hiker wishing to rest simply has to climb into their bag and close their eyes, hopefully sleeping under a thick blanket of outback stars.

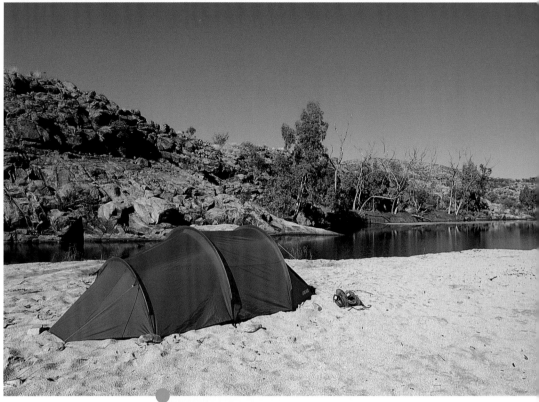

Inevitably, you often find you have company when camping overnight. Hinchinbrook Island was to be no exception, with the local population of rats taking considerable interest in our food. After a long day's hike, we would set up camp and cook a meal under the close scrutiny of the ever-hungry rodents. They would sit patiently just out of harm's way, waiting for the sun to set and for us to go to sleep, then the feast would begin. The main problem with the rats was that they were very determined, and a tent or rucksack was simply not going to stop them. Another problem was that we did not have enough food to feed both the local rat colony and ourselves, drastic measures had to be taken! Using fishing line we hung our rucksacks from a nearby tree, with all of our food split between the two bags and any evidence of the presence of food removed from the tent. We awoke to find a neat hole in Lynette's pack, unsurprisingly about the size of a rat, and a nibbled loaf of bread. For the next night's camping, we made a clothes line from the fishing line strapped between two trees and the packs were strategically placed in the middle. This seemed to work but I am sure that it was not from a lack of perseverance on the rats' part!

This has to be one of the more romantic methods for a night's sleep in the wilderness although it should be remembered that it does not offer any protection from wildlife or the elements. However, whatever your preferred means for a stay in the wilds you will always have many stories and memories from you trip – and probably a collection of inspirational wilderness photographs, all as a result of a night under the stars.

*The camping wilderness photographer should ensure that the tent is pitched to withstand any oncoming weather front. Although this may look a peaceful scene, we had been subjected to a severe storm the night before. Without the rocks positioned over the tent pegs to secure it on sandy ground, this may well have been a completely different picture. **West MacDonnell National Park, Northern Territory, Australia – 1/8sec at f/19, 24mm lens, polarizing filter, tripod, Canon EOS 300***

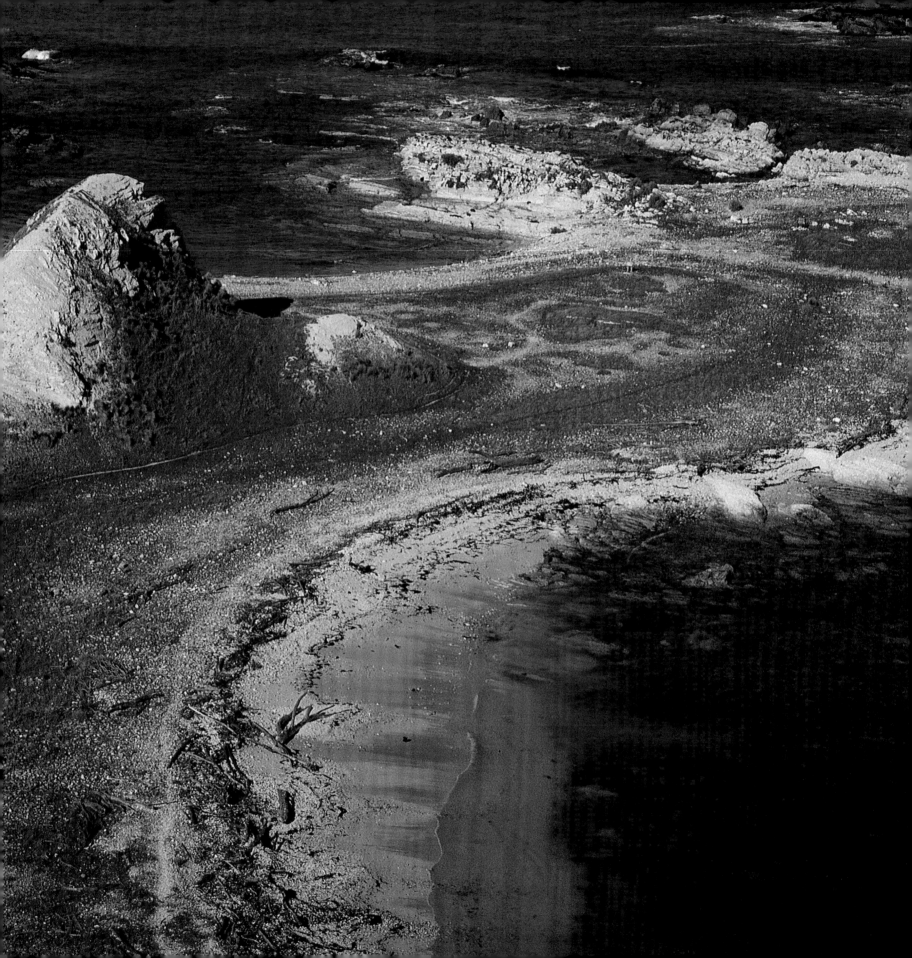

Techniques

Prints or transparencies?

Before you can load your camera with film and actually start to capture images you must first ask yourself what your intentions are for your final photographs. If you wish to show them to your family and friends, make prints to hang on your wall or maybe enter local camera club competitions, print film will suffice. If you hope to have images published, maybe in magazines or books, present a slide show or enter competitions, then you should consider the use of transparency film.

Kaikoura Peninsula and Sugarloaf Point, New Zealand – 1/30sec at f/19, 35–70mm lens, polarizing filter, tripod, Canon EOS 600

One advantage of using a fine-grained, slow transparency film is the increased degree of colour saturation especially within the green spectrum, making it the perfect film for woodland compositions. **Wakatipu Forest, New Zealand – 15sec at f/19, 24mm lens, polarizing filter, tripod, Cannon EOS 600**

This is not to say that the use of print film does not have its benefits. Using print film is the cheapest way of producing a final print. The two-stage process of making a print also means that it is possible to compensate for any errors you may have made when capturing the initial image, be it in the method of composition or actual exposure. Yet the disadvantage of using print film also lies in this process. If you choose to use print film, when you release the shutter you capture a negative image that then has to be printed for you to view a final, positive image. This means that your actual print is in fact a copy of the original image.

In contrast, when you take a picture using transparency film it is the final, positive image that you capture. Coupled with the means of viewing or reproducing a slide this generally means a greater degree of colour saturation, increased sharpness and less apparent grain. The drawback of using slide film is in the emulsion's near zero tolerance for exposure and composition errors. The only way to avoid disappointment is to bracket all exposures by capturing a sequence of frames both over- and under-exposed by 1/3–1/2 an f-stop, as well as double checking the viewfinder before actually taking any image. I would recommend the use of a slow-speed, fine-grain transparency emulsion for any serious wilderness photography as you will find the increased image quality compared to print film simply unquestionable.

Colour or black and white?

With the ever-increasing amount of glossy magazines gracing the shelves of news-stands, you would be forgiven for thinking that black and white photography is almost something of a forgotten medium. It is true that many magazine and book editors consider readers to respond more positively to images that show life in glorious colour. Luckily though, there are others who have not forgotten the raw beauty of a masterfully crafted black and white image and the emotional impact it can have.

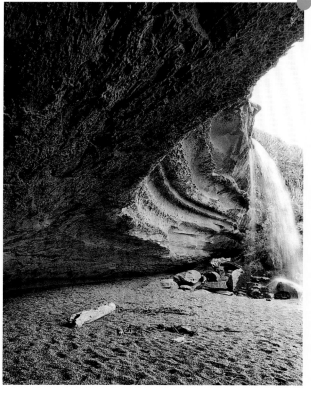

The real beauty of black and white film is its ability to convey the texture of a terrain. This image was captured using a C41 black and white film, which can be processed and printed in most high street labs, making the black and white medium available to the photographer without a darkroom. *West Coast, South Island, New Zealand – 1/10sec at f/19, 24mm lens, polarizing filter, tripod, Canon EOS 600*

This image demonstrates the importance of choosing the medium for the situation. This photograph would not have worked if shot on black and white film, as its success is due to the impact of the bold colours of the composition. *West MacDonnell National Park, Northern Territory, Australia – 1/6sec at f/19, 24mm lens, polarizing filter, tripod, Canon EOS 300*

Colour reflects reality and as such is the preferred medium for most landscape photographers. Unarguably, nature is the greatest artist known, so it is only logical that the photographer should wish to reproduce examples of it in its most natural form and colour. However, this is not to say that successful images of landscapes cannot be produced in black and white, sometimes focusing on light and form in this manner will convey an atmosphere all the more strongly.

Stripping the colour from an image will reduce it to the basic elements of shape, space and contrast. To compose a black and white image you must learn to interpret colour into the relative shades of grey and not be distracted by elements of colour. It was the godfather of black and white landscape photography, Ansel Adams, who introduced the concept of visualizing the final, printed image when composing a landscape photograph, rather than just seeing the scene as it looks in front of you.

The choice of colour or black and white is down to personal preference. You will find that your instinctual emotional response to a given landscape will influence your preference for the 'reality' of colour or the drama of black and white. The most important thing is that you feel you have successfully portrayed those elements of the landscape that made it distinctive to you at that moment in time.

Image orientation

Unless you are using a camera designed for a square image, you will need to decide upon the photograph's orientation. There are two choices: a horizontal, landscape composition or a portrait composition with the image framed vertically.

Landscape is the natural choice of framing for many a wilderness composition as this reflects how our own eyes view the world. Choosing to orientate your image horizontally will allow you to show the scene as a more traditional panorama.

However, a landscape will sometimes dictate the use of different framing techniques. A landscape with strong verticals will nearly always lend itself to the portrait composition. The key to success when composing a portrait image is that the photograph must have a strong focal point or it will fail. It is perfectly acceptable to hedge your bets when composing in the wilderness by framing a subject in both landscape and portrait format, although it is a very rare occurrence for both compositions to result in equally successful photographs.

Choosing a lens
Wide-angle

The wide-angle lens is by far the most versatile for the wilderness photographer to use. Without it, it's impossible to achieve depth of field in order to show the relationship between elements in a scene. The use of a wide-angle lens should be considered essential when your location has strong foreground interest as well as a spectacular backdrop. A wide-angle lens coupled with the use of a small aperture, such as f/19, will mean that every attribute of a composition will be sharp and the perspective will be natural. The viewer will be able to imagine walking the very lands that you have photographed.

It is essential that the wilderness photographer chooses the correct focal length for a certain situation, as opposed to being tempted to compose the image around the characteristics of the lens already mounted. **Monumento Naturale Caldara Di Manziana, Italy – shutter speed not recorded, at f/19, 75–300mm lens, tripod, Canon EOS 300**

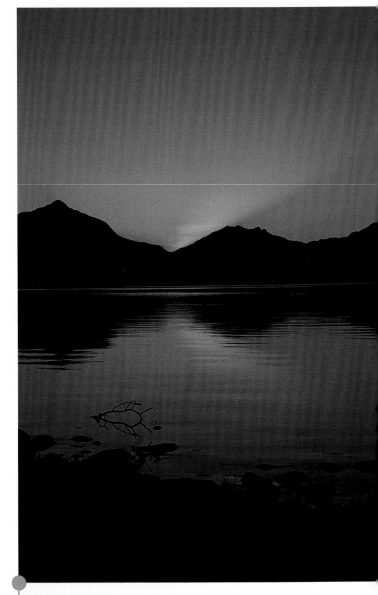

More often than not, the landscape will dictate the orientation of the image – very rarely will an image work in both portrait and landscape format. The landscape format is normally preferable for wilderness compositions, although the portrait format should not be ignored. **Lake Te Anau, Fiordland National Park, New Zealand – 1/30sec at f/19, 35–70mm lens, tripod, Canon EOS 600**

Standard

Increasing the focal length of your lens will compress the perspective to give a different look to the picture. The range of the standard lens has been likened to that of the human eye and if used wisely it can be employed to capture outstanding wilderness images. This focal length still offers the possibility for strong foreground interest but also an increased prominence to the other elements of the landscape. However, this is achieved at a cost to the composition, with the features seeming to merge and the depth of the composition diminishing drastically.

*The focal length of the 'standard' lens (50mm on 35mm equipment and 80mm on 6 x 4.5 medium format equipment) roughly mimics the angle of view that we see with our own eyes. Although this size focal length is not as versatile as the wider angles (i.e. 24mm and 35mm) it can still be utilized in certain situations to produce outstanding, natural-looking photographs. **Eildon Hills, Scotland – shutter speed not recorded, at f/16, 80mm lens, tripod, Mamiya M645J***

Telephoto

All perspective is flattened with the use of a telephoto lens. This is one of the benefits of using such a lens, ideal for photographing distant mountains or isolating details of a bleak landscape. The use of foreground is almost impossible with the longer focal lengths dictating that your composition will be almost two-dimensional. When this is coupled with dramatic lighting, it can produce truly outstanding compositions.

Wilderness composition – the golden rule

Before you can take a wilderness image you must first remove those elements of a composition that indicate a human presence (unless you have made a conscious decision to include the 'human touch'). This will mean taking the time before actually looking through your camera's viewfinder to make a mental note of anything

manmade or showing obvious signs of human intervention. This can take the form of power lines, roads or even low-flying aircraft. The introduction of any such thing within a wilderness photograph will eliminate the whole wilderness feel.

Essentially this is where wilderness photography differs from straightforward landscape photography. The wilderness photographer should always strive to convey the wild feel of a location and in doing so create something more evocative than a simple documentary shot.

Even the wildest of locations can show signs of human life, be it the damming of a river or a feint track running over the hills. They must all be omitted from your composition in order to achieve a picture that conveys the essence of wilderness. This also means that as long as these lands are protected, any photographs of them will remain timeless.

Although this may look like a pristine location, the consequences of human habitation on the nearby mainland have left a distinct scar. This beach actually more resembled a rubbish tip than a national park. The huge amount of rubbish washed up on the beach made photography difficult, although by implementing the golden rule of excluding any signs of human activity, a successful wilderness image was composed. **Hinchinbrook Island National Park, Queensland, Australia – shutter speed not recorded, at f/19, 35–80mm lens, polarizing filter, tripod, Canon EOS 300**

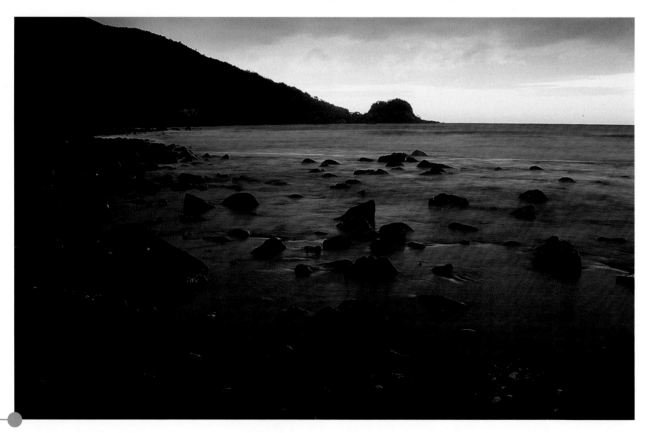

Working with the light

The key ingredient to a successful wilderness image, as with most fields of photography, is the quality of the illuminating light. For this reason, most landscape photographers prefer to photograph their locations during the rising and setting of the sun. The softness of the light at these times of day adds subtlety to photographs while evening light also has the benefit of adding warmth.

Lighting is the essential ingredient for any successful wilderness image. This is the very reason why most landscape photographers swear by early morning starts and late evening finishes. This is when the light of the sun is at its subtlest and often at its most dramatic. These two images show the values of the virtue of patience. The first shot, captured ten minutes before the second, has flat and unimpressive lighting and the sky is washed out due to the length of exposure required for the rocks. The second was captured after I had removed my camera, leaving the tripod in place. With my camera packed I turned round to move my tripod and witnessed this amazing play of golden light on the rocks. A lesson was learnt that has lasted with me since; if in doubt, wait and see. **The Devils Marbles, Northern Territory, Australia – 1sec at f/19, 35–80mm lens, polarizing filter, tripod, Canon EOS 300**

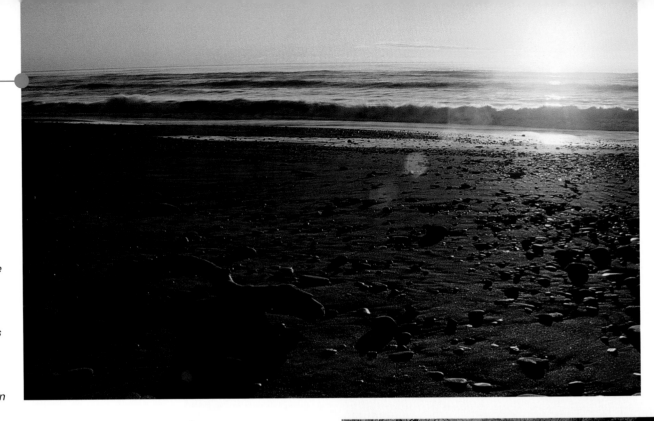

Choosing to use backlighting when photographing a subject can produce outstanding results although the composition must be scrutinized through the viewfinder before finally releasing the shutter. The main concern is the presence of flare. The only way to avoid flare is to not shoot towards the light source, obviously not always possible when using the backlighting technique. To minimize flare a good quality lens hood should be utilized and the use of filters kept to a bare minimum. If possible the light source, the setting sun for example, should be hidden behind a natural formation. **West Coast, South Island, New Zealand – 1sec at f/19, 35–70mm lens, tripod, Canon EOS 600**

Unfortunately, it is not always possible to photograph some locations when the sun is low on the horizon and the light is softer. Sometimes this is due to problems with access to the area, particularly an issue for day hikers, but there are also locations, such as valleys and gorges, that are not illuminated until the sun is high in the sky. This will mean that the light is harsh, although in this situation harsh light is preferable to taking pictures at a different time of day without any illuminating light.

There are many scenes that actually benefit from flat and dull diffused lighting. For example, the inclusion of sunlight to a woodland scene will often produce a composition with too high a level of contrast to be recorded on transparency film. Waterfalls also benefit from diffused light with the elimination of any hot-spots on the water's surface. Photographs of water also often benefit from the long exposure required to compensate for dull conditions, as this is an effective way to convey the ephemeral nature of flowing water.

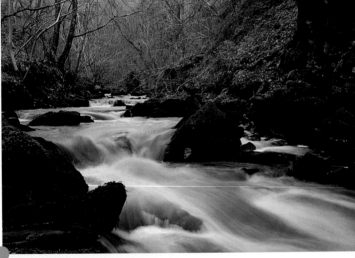

Surprisingly, sometimes it is the lack of light which will provide the ideal conditions for wilderness photography. Here the overcast sky has resulted in bright but flat, diffused lighting – eliminating any highlights from the water's surface as well as allowing for the use of a longer exposure to help convey the movement of water. **Haltwhistle Burn, Northumberland, England – 1sec at f/16, 80mm lens, 81B filter, tripod, Mamiya M645J**

Leading the eye

It is important to frame a photograph so that the eye is led into it. Using this technique you can draw the eye towards points of particular interest and encourage anyone looking at the picture to engage with it more.

Rivers flowing through valleys and gorges will lead the eye through the landscape, as will a waterfall flowing down a bank of rocks. However, it is not just water that will provide a lead for the eye. The key is to envisage the landscape as a group of lines and shapes and to create your photograph around any elements which lead into, and not out of, the frame. The natural patterns of rocky outcrops or the presence of a natural fallen tree for example, will serve for this purpose.

Some landscapes do however require closer scrutiny and some will lack any natural leads for the eye. In this case, the use of warm light and strong shadows is essential. Long shadows are another advantage of photographing locations at times when the sun is low on the horizon.

By incorporating these shadows in your composition, it is possible to acheive the same leading effect as that created using the lines of physical features.

The disadvantages of using light is that unless the sun is low, the contrast levels of the image will probably be far too great to capture on transparency film, although the use of certain filters will help to balance the contrast in some situations.

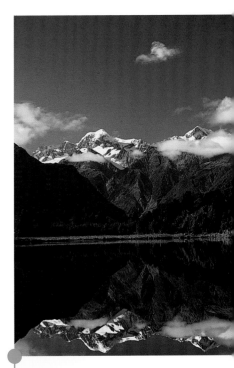

TIP

Flowing water will always serve well as a leading factor for the eye.

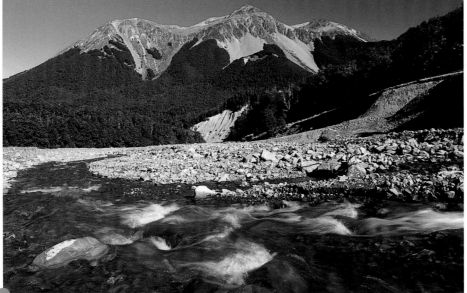

A flowing river, when captured through a wide-angle lens, will quite often produce an excellent way of leading the viewer's eye into the final composition. A flexible and sturdy tripod is often essential for this kind of image, as is a good pair of waterproof hiking boots! The key is to make the water the dominating feature of the foreground, naturally leading the eye towards the horizon of the landscape. **Braided River, Craigieburn Forest Park, New Zealand – 1/10sec at f/19, 24mm lens, polarizing filter, tripod, Canon EOS 600**

You should never be afraid to experiment. As a general rule for reflections, the image should be divided into two, mirroring vistas. However, here I chose to utilize the rule of thirds, which made this composition, of what is a highly popular photographic viewpoint, quite unique. **Lake Matheson, New Zealand – 1/4sec at f/22, 35–70mm lens, polarizing filter, tripod, Canon EOS 600**

The rule of thirds

This is the fundamental principle for anyone that creates pictures, whether they are a painter or a photographer. Using the rule of thirds will ensure that the final composition is balanced and hopefully pleasing to the eye.

To use the rule, you must first imagine the frame divided by two vertical and two horizontal lines, both positioned an equal third into the frame, creating an invisible grid over your composition. Now you must look at the dominating features of the landscape and frame them around your imaginary gridlines. For example, if the horizon is to be included within the image it must be positioned high in the top third of the frame, or if foreground interest is a more important factor you should compose your photograph with any prominent foreground located in the left or right side area of the lower third. You should avoid any prominent features being located in the central area of the grid unless a strong lead in for the eye is present in the lower thirds. This is a common mistake for the untrained photographer's eye and will ultimately lead to an unbalanced photograph.

However, there are exceptions to this rule. If the dominant feature of your composition is a reflected landscape, particularly if it is a very clearly mirrored image, you should locate the point where the reflections meet in the centre of the frame. This is because a reflected landscape is essentially an image in two sections; composing the picture to the rule of thirds would mean removing the emphasis from the main feature of the image.

TIP

Always be aware of the rule of thirds when taking pictures.

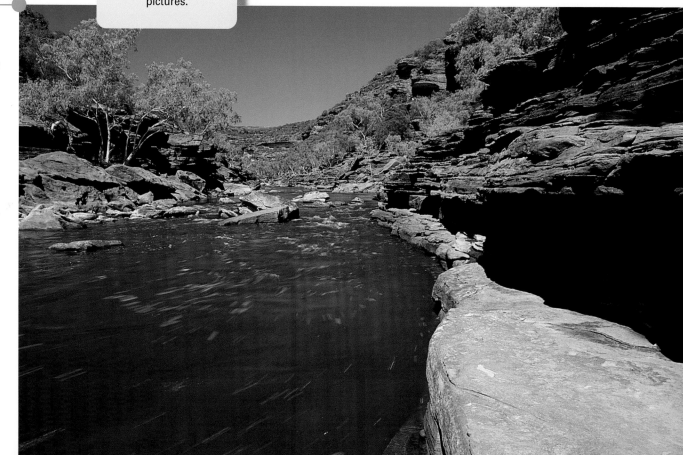

The rule of thirds is a basic composition technique that is valuable to the wilderness photographer. With practice, the framing techniques of the rule of thirds become second nature. **Z-gorge, Kalbarri National Park, Australia – 1/6sec at f/19, 24mm lens, polarizing filter, tripod, Canon EOS 300**

Composition and form

It is important to employ both the golden rule discussed earlier and the rule of thirds when taking wilderness photographs, but there is another element which is fundamental to the final image – the texture and form of a landscape.

Low lighting is certainly the easiest way to include texture and form within the landscape. It illuminates the landscape without the risk of hot-spots and flares on the vista and the long shadows emphasize the rolls and crevices of the landscape's features.

The natural world creates many patterns that can be used to create pleasing abstract photographs. For example the ripples of sand dunes carved by the wind or a mosaic of lichen covering a rock can be used for a simple composition that explores the essential elements of form. Interesting effects can be achieved by concentrating on these small sections rather than the complete object or scene, filling the frame with pattern or shapes. This technique is most effective when all reference points to scale are eliminated.

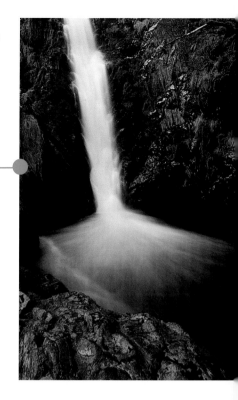

By painting the smaller picture, it is possible for the photographer to compose images under less than ideal lighting conditions. A white featureless sky will always distract the viewer's eyes from the main composition. It could be considered a bold step, but if the horizon does not benefit a composition it should be omitted.
Linhope Spout, Northumberland, England – 10sec at f/19, 24mm lens, combined 81A and polarizing filter, tripod, Canon EOS 300

Successful compositions can be achieved by studying the natural patterns and textures to be found within the landscape. This is not to be confused with macro work. The main objective for this kind of photography is to compose an almost abstract image of a recognizable subject.
Native Fern, Able Tasman National Park, New Zealand – 6sec at f/19, 35–70mm lens, polarizing filter, tripod, Canon EOS 600

Framing for poor weather

Although it is undeniable that bright, clear days provide the most reliable opportunities for well-lit images, it is still possible to compose striking photographs in poor weather. In fact, these kinds of conditions, coupled with a few basic techniques and a little foresight, result in some of the more dramatic and memorable wilderness photographs.

Pictures captured in poor weather will often take on an almost monochrome feel. In particular, the lighting often encountered before a storm will record as an atmospheric blue. This effect can be enhanced by using an 80B 'cool-down' filter. Unfortunately, photographs captured under such conditions are quite often something of a gamble with the key to success being in deciding the required time of exposure to the emulsion. As a guideline you should try to take a centre-weighted evaluative reading for the exposure and then underexpose the shot by one stop, ensuring that you bracket your exposures widely.

It is essential that you bracket your exposures widely when capturing an image that cannot be repeated. I learnt the hard way. When visiting the Volcanoes National Park found in Hawaii, my partner and myself hiked out one night to witness the hot flowing lava from the eruption of the Kilauea volcano. I had found a good viewpoint to photograph the lava and then, largely due to the intense heat of the lava, I left the judgement of the exposure metering to the camera's centre-weighted metering system. This was a huge mistake, with all of the images being underexposed. I now bracket extensively and shoot lots and lots of film.

Poor weather will often produce memorable photographs, although the photographer will require a degree of foresight as well as an understanding of how the film they use reacts under low levels of light. Rain is often present in periods of poor weather and this is when the humble umbrella proves to be a useful accessory. Cheaper than a purpose-made camera 'rain jacket', the umbrella not only shields the camera from downpours but will also prove to be an excellent lens hood when photographing in overhead light. It is also useful for the changing or cleaning of lenses and filters and can even be used by the photographer to shelter from a shower of rain! **Lake Mahinapua, West Coast, New Zealand – 1/2sec at f/22, 35–70mm lens, polarizing filter, tripod, Canon EOS 600**

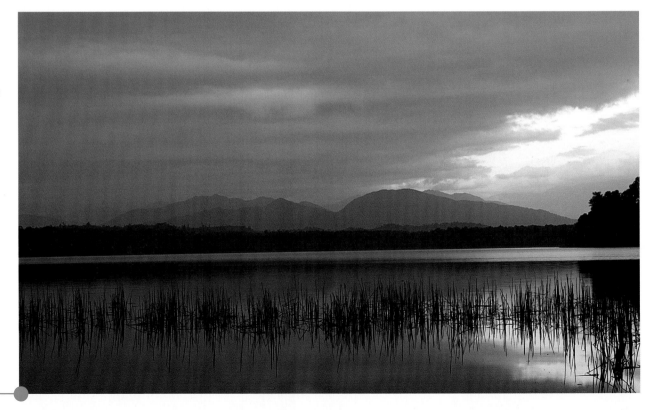

However, sometimes you will find you have to work with a featureless sky and then you must take the decision of whether to omit it – if in doubt, leave it out! Choosing to leave a featureless, grey sky within a composition can destroy what could otherwise have been a successful image. When framing your photograph you should also consider the areas of the viewfinder that will not be included in the final image. Depending on the equipment you use, this could be as much as 10 per cent of the actual frame.

When to use a filter

The key to the successful use of filters when composing a wilderness photograph is that the effect should be undeterminable to the untrained eye. This means that filters should be used marginally, and only when the composition of a landscape dictates it.

Many photographers prefer to keep a clear skylight filter attached to their camera at all times. This is primarily to protect the glass of the lens from damage, as well as helping to penetrate any atmospheric haze when capturing an image.

The polarizing filter is the most versatile of filters. It can be used to penetrate haze but has many additional benefits. When used at 90 degrees to the sun it is at its most productive. By turning the filter a clear sky will become a striking deep blue, especially effective if fluffy white cirrus clouds are present. The filter will also change the colour of water by eliminating any glare from the surrounding landmass and sky. The elimination of glare will also help to saturate the colours of foliage, introducing a bold element to your photographs.

However, the degree of polarization applied when using the filter should be restrained. In some conditions, by utilizing maximum polarization, blue skies can become black, as well as unwanted vignetting occurring due to polarization.

TIP
Be careful when using skylight filters as they can add to vignetting when extra filters are attached.

Transparency film does not possess the same degree of exposure latitude as inherent in negative material. Consequently, for the photographer to capture an image of a landscape consisting of high levels of contrast, it is necessary to employ the use of neutral density graduated filters. These filters are available in varying degrees of strength, as well as a hard and soft transition from clear to neutral density. It is also possible to buy these kind of filters combined with the 81 range of warm-up filters. For example, an 81B warm-up lower half, graduating to a 0.6 (2 f-stop) neutral density filter. **Lake District National Park, England – 1/6sec at f/19, 35–80mm lens, 0.9 neutral density graduated filter, tripod, Canon EOS 300**

By careful focusing techniques and ensuring you set your wide-angle lens to a small aperture, it is possible to record an image with a depth of field covering the complete panorama. If your camera system has a depth of field preview, you may also ascertain the degree of sharpness throughout the image and fine-tune your focusing, before actually releasing the shutter.
The Devil's Marbles, Northern Territory, Australia – 1/6sec at f/19, 24mm lens, polarizing filter, tripod, Canon EOS 300

It should be remembered that some lighting situations will simply not record effectively on transparency film. However these scenes, normally containing high levels of contrast, are photographed by the use of neutral density graduated filters. This type of filter works by increasing the exposure required on the graduated grey coloured area of the glass. These filters are available in various strengths including 0.3 (1 f-stop), 0.6 (2 f-stops) and 0.9 (3 f-stops). To determine the strength you require for a scene you should take a spot-metered reading from both the illuminated and non-illuminated features and evaluate the difference of exposure required. If using your camera's TTL metering, you must determine any exposures before attaching the filter to the camera.

The 81(warm-up) range of filters are another useful accessory for the wilderness photographer. Again they are available in a variety of strengths, with the 81A, 81B and 81C being generally the more useful and 'believable' filters. They are invaluable in low-light situations where without their use a cool blue colour cast could appear on the final transparency. They are also useful for warming a scene in general, rendering your composition with a hint of sunshine. However they are by no means a substitute for good light. Restrained use of the filter can also be effective in emphasizing the preferable properties of warm illuminating light.

In complete contrast to the 81 range, the 80 (cool-down) series of filters can be used to exaggerate low light to create an interesting atmosphere, or to inject a dawn feel of lighting to a composition. The 80B filter is especially useful for scenes containing water, where the blue colour effects of the filter can complement and possibly improve the scene. It is also possible to utilize this filter in various other situations, although it is not generally as useful as the other filters mentioned.

Choice of aperture

The aim of the wilderness photographer is to capture the panorama of a landscape within the confines of a frame. Unlike in other fields of photography, this kind of image is most effective if all the features are razor-sharp throughout the whole image. The only way for the photographer to achieve this is to use a small lens aperture and a basic focusing technique.

The choice of aperture is governed by the specifications of the lens used. The smallest aperture available will render the maximum depth of field, however this setting should be ignored as the optics of the lens system are impaired when using the lowest aperture. Instead choose the next largest setting. Confusingly, this will actually be the next smallest f-number on the lens body.

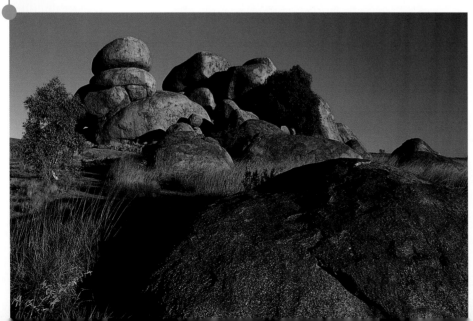

TIP

Remember that a high f-setting on the lens will indicate the use of a small aperture, and visa versa.

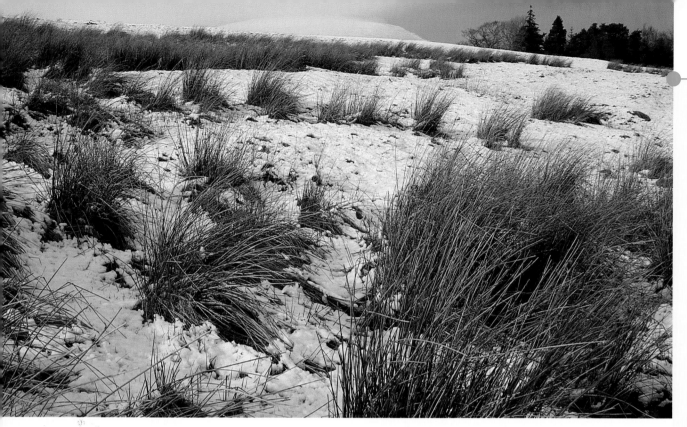

However, even when using a small aperture to maximize depth of field, you will need to focus the lens very precisely to ensure sharpness throughout the image. There are many technical theories of how best to do this, with the following method proving to be very reliable.

Most lenses display a distance scale on the barrel, adjacent to the scale of f-settings. By choosing to refer to this scale when focusing, the photographer can gauge by comparing the chosen aperture setting to the minimum and maximum distances, the actual areas of the image to be recorded pin-sharp. The simple way to maximize depth of field is to focus your lens by turning the barrel until the infinity symbol (∞) coincides with the chosen aperture on the reference scale. This may not appear to be an accurate focusing technique when actually looking through the viewfinder, but will provide a reliable method to ensure maximum depth of field on the final recorded image. Users of equipment with a depth of field preview function, will be able to view how their image will finally appear before triggering the shutter release, invaluable for any last minute fine tunings to the focusing.

Choice of exposure

The wilderness photographer using a modern 35mm SLR is in a position where under most circumstances they can rely upon the camera's complex TTL metering system. However, some situations will trick the camera's meter, no matter how sophisticated the system, and the photographer will be obliged to manually select the length of exposure.

A handheld light meter with a spot-metering facility provides the means to take exposure readings from various points within the frame and evaluate the actual exposure requirements themselves. For accurate exposure you will need to take a reading from a mid-grey tone, or a colour resembling the same properties for metering, such as the mid-tone green of healthy foliage. This tone should be a highlight of the scene for successful rendition on transparency film. If using black and white negative film however, this reading should be obtained from the shadows. This is due to the level of control you have when printing the final positive print. A transparency exposed for the low-lights would appear washed out from overexposure.

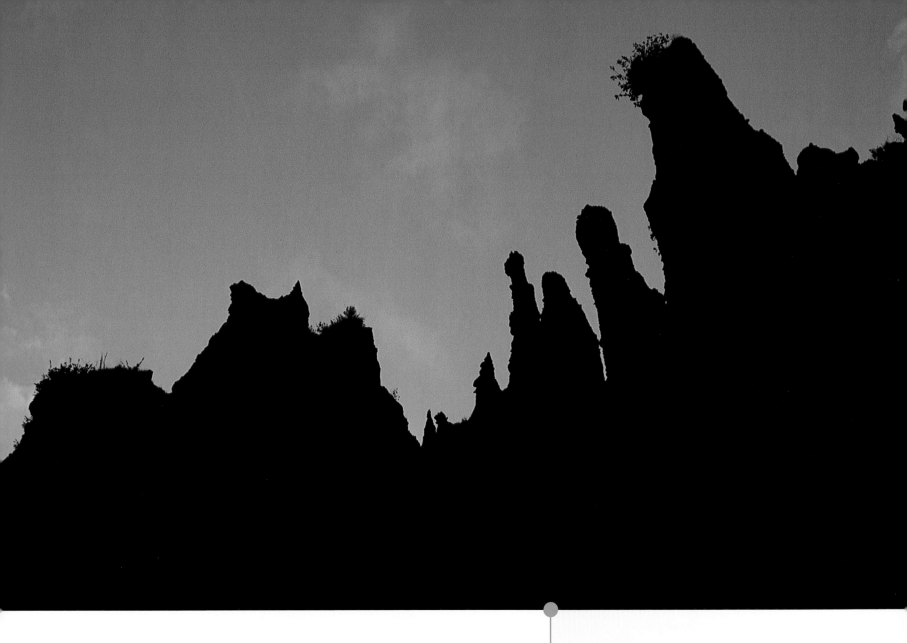

Sometimes, there are no mid-grey tones within a composition meaning that the photographer has to decide the exposure using an alternative technique. An 18 per cent grey card provides the means to accurately evaluate the exposure. However this will require taking a spot-metered reading off a card receiving the same levels of light as the prominent, high-key features of the composition.

It is possible to take readings off objects which do not evaluate to a true 18 per cent mid-tone, although adjustments to the reading will have to be made. The extremes of these alterations will depend on the colour

It is sometimes necessary to take a spot-metered reading from something other than the main subject. Here, a small pocket of blue sky lingered behind the un-illuminated pinnacles, so I chose to take a metered reading from a section of the sky, which subsequently made this unusual rock formation a silhouetted image, as well as making it appear almost two dimensional.
Putangirua Pinnacles, New Zealand – 1/15sec at f/19, 35–70mm lens, tripod, Canon EOS 600

of the subject. If taking a reading of a prominent white subject, the exposure would need to be extended by up to 2 f-stops. On the other hand, if the feature was black, such as some rocks of volcanic origin, the reading would need to be reduced by 2 f-stops. This is due to the metering system being tricked by the light-reflective qualities of white and the absorbing features of black. It is recommended that the wilderness photographer brackets the final exposure by taking three exposures, the correct reading, one being reduced by 1/2 f-stop and one plus 1/2 f-stop. Many modern cameras offer a function for this to be automated effortlessly.

TIP

Remember that any metering system will only be accurate if the tonal quality of a metered landscape is mid-tone.

The preferred degree of exposure for a wilderness image is something of a personal choice and depends on the photographer's style. Some prefer the bright, 'chocolate box' image whilst others, like myself, prefer a darker and somewhat moodier image. **Budle Bay, Northumberland, England – 1/8sec at f/16, 80mm lens, 0.3 neutral density graduated filter, tripod, Mamiya M645J**

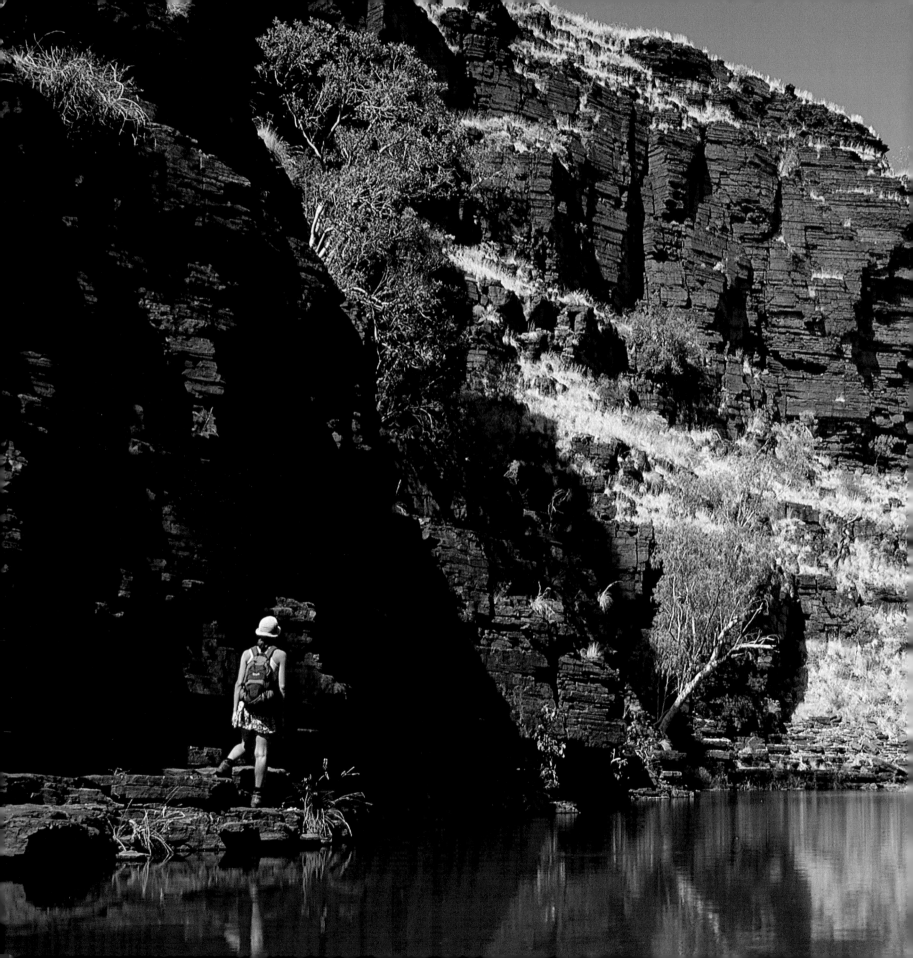

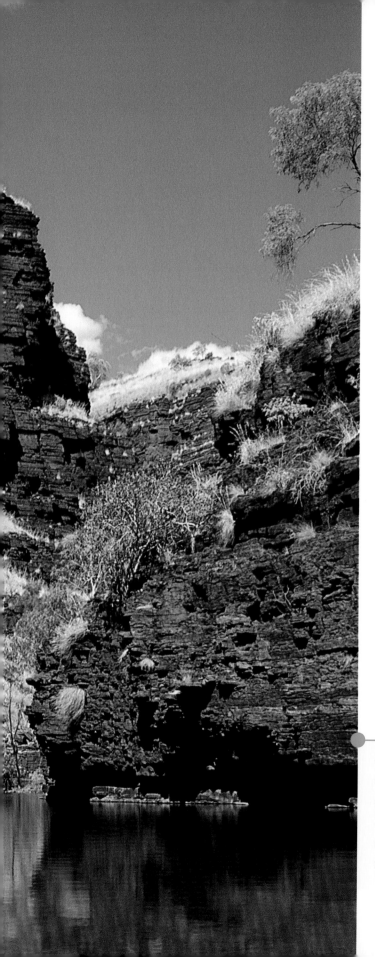

The human touch
– people within the wilderness

You will probably find that as you begin to take
wilderness photographs, you will start striving to capture
images free of any kind of human intervention and
especially of humans themselves. The wilderness
photographer with a purist approach would argue that
this is indeed the only way to capture a true wilderness
landscape image. However, there are occasions when
I would have to disagree.

Knox Gorge, Karajini
National Park, Western
Australia – 1/3sec at f/19,
35–80mm lens, polarizing
filter, tripod, Canon
EOS 300

A wild landscape image that includes the distant figures of people will lose most of, if not all, its essence of wilderness. Colour can be another problem with clothes often made in 'advancing colours' meaning that they attract the eye and therefore they become the most prominent detail in a photograph. The kind of clothing worn can actually influence whether the landscape appears tame or hostile. Furthermore, if the person in shot should happen to dominate the frame then the image will become a casual portrait, focusing attention on the human element. Patience is vital as it will result in more productive photography. If you are visiting and photographing an area that is unlikely to be deserted you should always remember to double-check the viewfinder when composing your image, only triggering the shutter release when you are sure that the shot is completely free of people. However in some instances, and with a little careful attention, the human figure can add the finishing touches to a photograph.

Although it is disappointing when stray walkers wander into shot, and frustrating to have to wait for what seems like a lifetime to capture a people-free shot, there are distinct advantages to visiting a popular wilderness area. An instance on the Copeland track, a seven-hour trail acting as a gateway to the impressive Southern Alps of New Zealand, is one example of this. We had planned to walk the trail one way to a hut, where we would spend the next couple of days exploring the area and then return to our parked vehicle by the same route. However, heavy rain made exploring impossible due to safety considerations and we found ourselves spending more days in the hut than expected. When the rains finally did lighten, we decided to walk the trail back, only to find that the gentle streams we had once rock-hopped over had become torrential currents powerful enough to drag a human downstream to a possible watery grave. The only way for us, and the many other people descending the mountain, to cross these once tranquil streams was by joining together to form a human chain and for each hiker to cross the stream holding on to this chain. The wilderness can be a dangerous place, but without the help of fellow humans it can be a killer. I try to remember this every time I have to wait for a scene in my viewfinder that is free of people.

The use of the human figure within a composition can add scale to an expanse of wilderness. If you cover the hiker located within the lower right-hand corner of the frame, you will find that the size of the landscape becomes incomprehensible, as well as failing to have a true focal point for the eye. **Tongariro National Park, New Zealand – 1/6sec at f/19, 35–70mm lens, polarizing filter, tripod, Canon EOS 600**

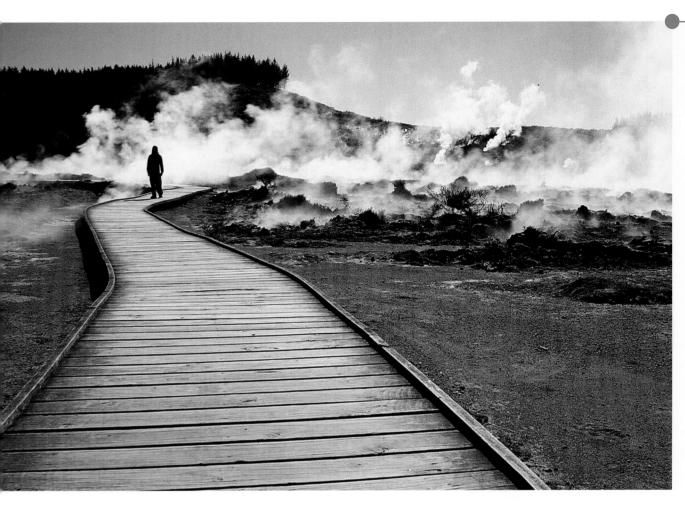

Here the wildness of the location has necessitated the installation of boardwalks for visitors. Although I would not normally include a feature such as this that indicates a human presence, here, coupled with the distant human figure, it demonstrates mankind alongside the forces of nature.

*The human element is essential for the success of this image. **Craters of the Moon Scenic Reserve, Wairakei, New Zealand – 1/10sec at f/19, 35–70mm lens, polarizing filter, tripod, Canon EOS 600***

The benefits of incorporating a human figure into a composition can be great. It will nearly always add scale to a picture, allowing the image to convey a clearer sense of the surrounding landscape. They can also make an image more accessible and therefore more appealing to a greater audience. In addition, the human figure can be included to evoke different emotions, such as loneliness or adventure, as well as portraying a feeling of open expanse. People can also make excellent focal points for images captured in landscapes which are bleak or otherwise featureless.

TIP

When including people in landscape shots, try to avoid bright clothing that will detract from the natural landscape.

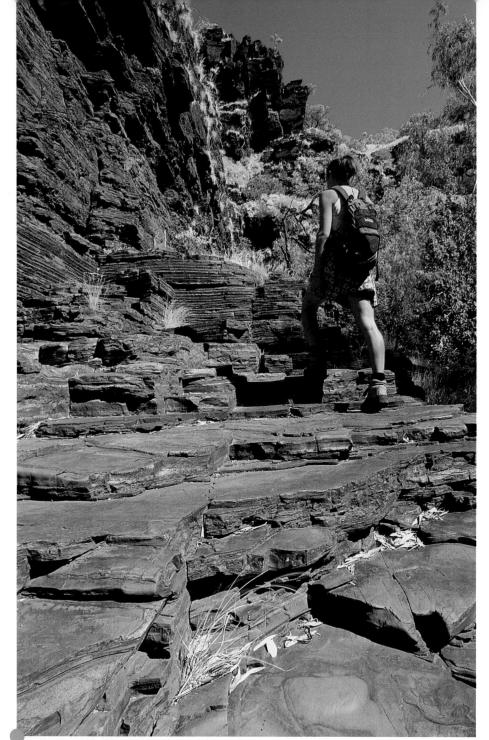

Composing the image

By placing figures in the distance you can greatly improve a composition. This technique will significantly increase the depth and scale of a picture as well as implying a sense of exploration. Posture is critical even if the model is only playing a small role in the final composition. Communication over a large distance is difficult so brief your model about your intended shot and try to establish a means of informing the person when they are in the correct position and when you have finally captured the shot. You should never conceive a system utilizing flares, torches or whistles as these could all be interpreted by any passer-by as a signal of distress. Always think before you act when you are in the wilderness.

TIP

If you are using your figure as a focal point you must ensure that your model's eyes are not looking towards the camera's lens. Encourage them to face the opposite direction as if they are admiring the landscape.

*Although some images will work as people-free shots, they may also benefit from the inclusion of people. The introduction of a hiking figure roughly two thirds into the frame helps to convey a feeling of exploration. **Knox Gorge, Karajini National Park, Western Australia – 1/3sec at f/19, 24mm lens, polarizing filter, tripod, Canon EOS 300***

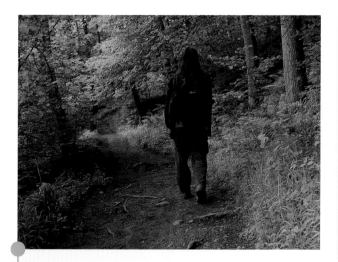

To capture an image of a walker in low-level light conditions, it is essential that the model is asked to pose perfectly still. The model here was asked to remain in a walking position while I captured the image using a relatively long exposure. ***Allen Banks, Northumberland, England – 1sec at f/16, 80mm lens, polarizing and 81B filters, tripod, Mamiya M645J***

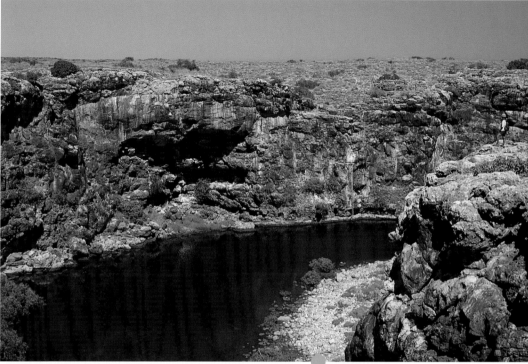

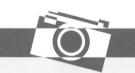

TIP

It is worth noting that due to the length of time normally required for a large depth of field, especially a problem within forests, the model must be perfectly still to eliminate the possibility of a partly blurred image.

Accurate composition is critical when including the human form, as there can be a fine line between a wilderness image including humans and a portrait with a wilderness background. It is essential that the shot doesn't look contrived and that the people in it are behaving naturally. By asking your model to wear a back-pack and simulate a walking position you can instil a sense of exploration in your image. Here the use of space is essential, by leaving room behind and in front of the model, and utilizing the rule of thirds, your composition will appear balanced with an increased sense of movement.

It is not necessary for the human form to dominate the frame. Even by placing the figure far in the distance, the essence of the wilderness photograph will have been changed. As with all techniques, the human touch should be included only when the landscape dictates it. ***Yardi Creek, Cape Range National Park, Western Australia – 1/30sec at f/19, 35–80mm lens, polarizing filter, tripod, Canon EOS 300***

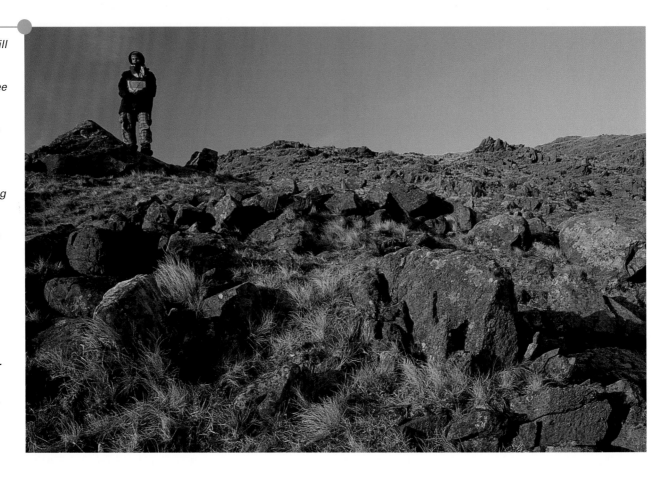

As ever, good lighting will always improve a composition – people-free or not. Exposure techniques are the same as for any wilderness landscape, with the preferable methods being to take a spot-metered reading from a mid-tone or a direct reading from the light source through the use of an ambient light meter. **Martcrag Moor, Lake District National Park, England – 1/2sec at f/19, 24mm lens, combined 81A and polarizing filter, tripod, Canon EOS 300**

Lighting your image

There are no real problems associated with exposure metering techniques when you include the human form within a composition. As the wilderness photographer actually only includes people to support the wilderness, it makes sense that any exposure metering should be made from the landscape and not the person. With the exception of intending to compose a picture with backlighting, you should ensure that your models are located in a position where they receive the same amount of illuminating light as the main features of the landscape. As a result, when you do finally take a metered reading from a mid-tone feature in the landscape, possibly grass or rocks, the exposure will also be accurate for your model.

You would however find it virtually impossible to take an accurate metered reading off your models' clothing, unless they should happen to be made of a mid-grey coloured material.

The main consideration for this kind of photography is to know when to include the human form within a landscape. This is where you will benefit from experience although if, when photographing a landscape, you feel that you cannot accurately convey the size and grandeur of a place, or if your composition of a wild, open vista has no focal point, then it is worth trying the inclusion of a human presence. It could make the difference between an image being spectacular or merely adequate.

Although sunsets can be spectacular to photograph, without interesting cloud formations or good foreground interest, they can be compositionally poor. The human figure can be included to provide a foreground interest, although it is essential that the exposure is based around a metered reading taken from the setting sun and not the person. This will ensure that the figure becomes a silhouette and that the dominating factors of the image are that of the natural environment. **Lakeside, Cape Range National Park, Western Australia – 1/20sec at f/19, 35–80mm lens, star filter, tripod, Canon EOS 300**

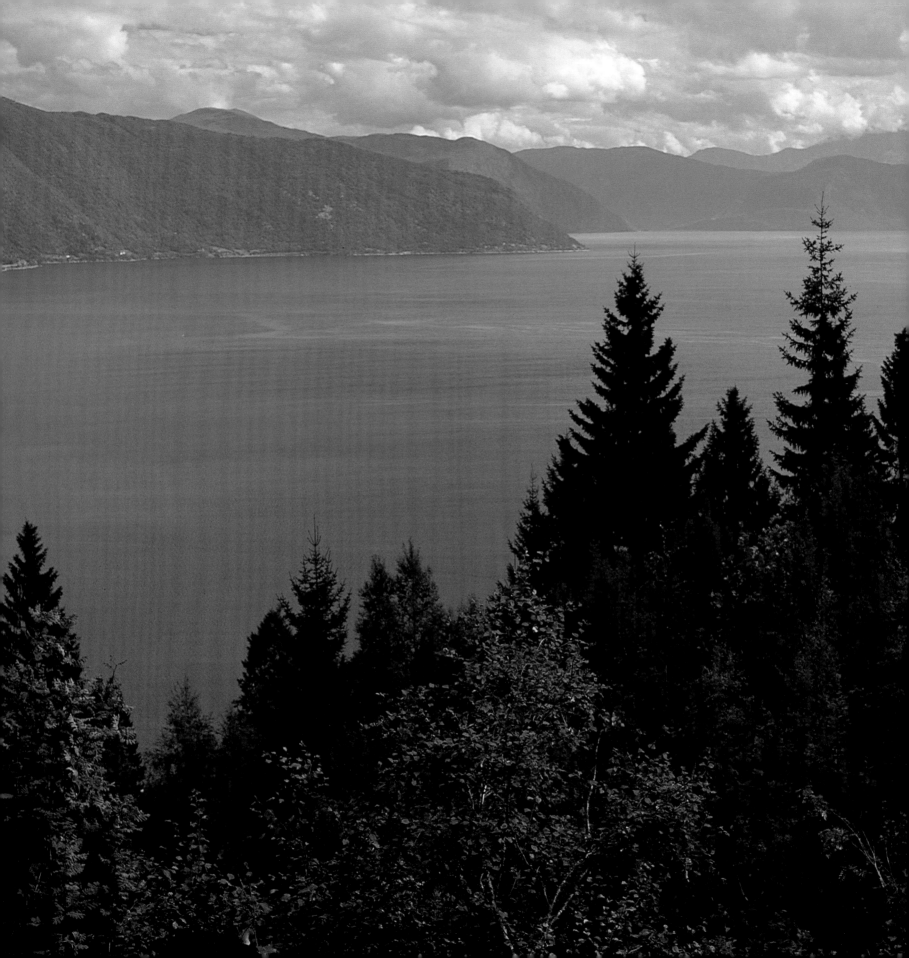

Urban wilderness

One would be forgiven for presuming that you have to visit true areas of wilderness to be in a position to compose images of wild and dramatic landscapes. However it is quite possible for the photographer to convey a sense of wilderness in areas with large expanses of human development. The photographers' goals have not changed although the means of achieving the final image have to be adapted to the location. It is crucial to get the most out of any area visited. Sometimes, you may find yourself visiting a place en route to your final destination, allowing you only limited time.

Balestrand, Sogn Og Fjiordane, Norway – 1/6sec at f/16, 80mm lens, polarizing and 0.6 neutral density graduated filter, tripod, Mamiya M645J

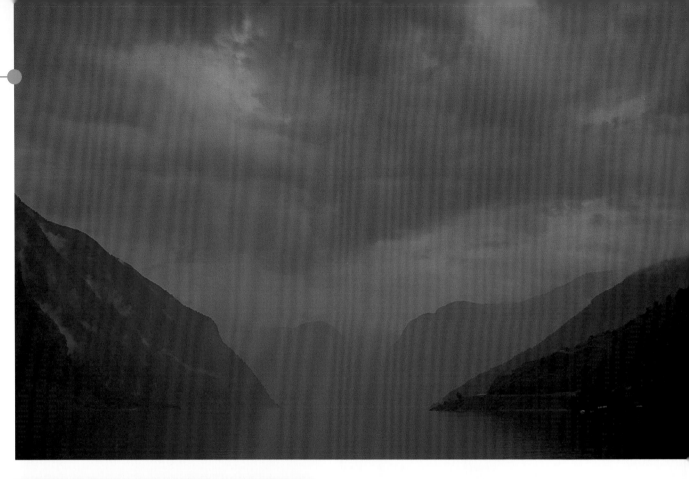

Although it is often beneficial, good illuminating light is not always essential for a successful urban wilderness image. Here the mood of the oncoming storm has been maintained by using a neutral density graduated filter to ensure even lighting throughout the frame. **Aurlansfjordan, Norway – 1/10sec at f/19, 35–80mm lens, 0.9 neutral density graduated filter, tripod, Canon EOS 300**

When photographing coastlines it should be remembered that it is not just the sea that will produce a pleasing composition, but also the vegetation of the surrounding environment. **Budle Bay, Northumberland, England – 1/2sec at f/16, 80mm lens, polarizing filter, tripod, Mamiya M645J**

Working with water

Water, as well as always making for an interesting composition, is essential to human survival so the location of villages in close proximity to it is not surprising. Wherever you are in the world, coastal areas are one of the most productive locations for wilderness photography. Seascapes are enjoyable images to compose and the wilderness feel can be portrayed relatively easily.

The rules for composition are the same as for any kind of wilderness photograph, although particular attention has to be paid to omitting any signs of human presence. The major bane for the coastal photographer is the many boats to be found surrounding the coastlines of the world. In less developed parts of the world, small fishing boats are often seen, harvesting an important food source for the local townships that are reliant on a regular supply of fresh seafood. More developed countries are home to commercial vessels, from fishing boats to passenger liners, and here the chances of finding a stretch of pristine, uncluttered coastline become even less.

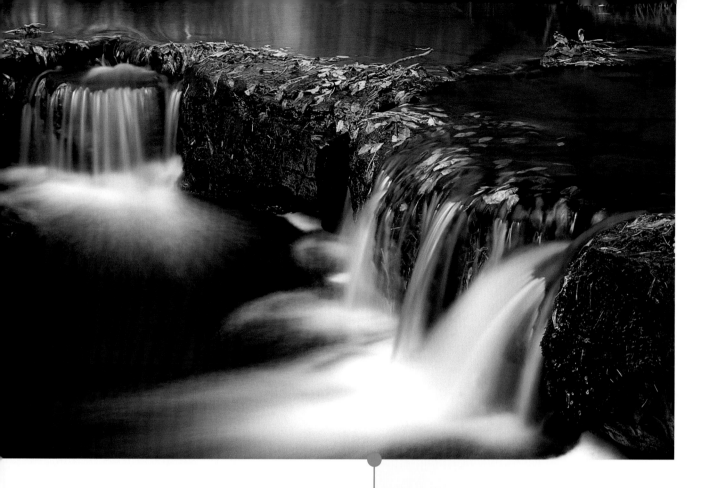

The wilderness photographer should always have options. If you cannot paint the big picture, you should start to be more selective. Replace the almost obligatory wide-angle lens with a larger focal size (for example 200mm or 300mm on the 35mm format) and concentrate on the key features remaining of the wilderness. The small landscape, not to be confused with macro work, holds its own niche in the world of the urban wilderness photographer. Rocks and surf always make excellent subjects and, if coupled with golden rays of warm light, can provide outstanding compositions. Even a close crop of the distant horizon can make for an interesting image, although it is critical to observe the rule of thirds during composition.

Often the quality of light will make or break this kind of photograph but, as with any element of outdoor photography, forward planning, patience, a desire to experiment and a measure of good luck will help to achieve successful compositions.

To compose a wilderness image in the urban environment it is sometimes necessary to frame the photograph around a certain element of the landscape – this could be referred to as painting the small picture. A telephoto lens can be useful for this kind of photography. **Hareshaw Burn, Northumberland National Park, England – 4sec at f/19, 35–80mm lens, combined 81A and polarizing filter, tripod, Canon EOS 300**

The rules are essentially the same for any location of human habitation in close proximity to water, be it the sea, lake, river or waterfall. The problems for the photographer are greater in some areas of developing countries where tourism is not so common. One such problem being that the water source will often supply not only food and drink, but will also be an area for local bathing and washing of clothes, creating complications for the photographer. Be polite; don't take pictures of local people without their permission. If someone does not want their picture taken, make a point of emphasizing the opposite direction of the composition. Better still, leave your photography for the times of early morning and late evening, when not only will the light be more favourable, but the waters will be less busy. It is unwise to flaunt your camera equipment, bearing in mind that it may well be worth more money than a local person would receive in one, or even ten, years of hard work.

TIPS

Be discreet with your equipment. By handling it openly you could be putting temptation in the path of an opportunist thief and offering them a golden opportunity.

The very reason for a location being popular with tourists is often an abundance of photographic opportunities. However, the visiting photographer will normally have to stray off the beaten track to seek viewpoints free from tourists. For this image, I found myself wading around the rocky outcrop to reach this secluded bay. **Long Beach, Pulau Perhentian Kecil, Peninsular Malaysia – 1/8sec at f/19, 24mm lens, polarizing filter, tripod, Canon EOS 300**

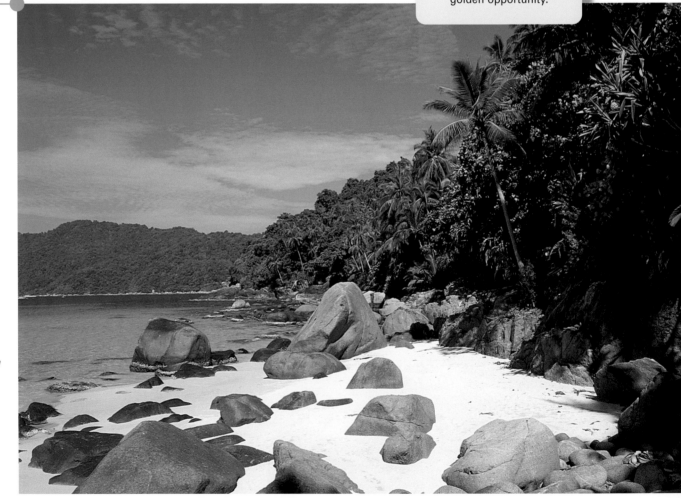

Photographing woodland

Urban woodlands can also offer ample photographic opportunities. Here you will find that the forests are less dense than in the wilderness. This is often due to trees being felled for timber or to the woodland being managed, with trees that are damaged or leaning being felled, so that it can be used safely for recreational purposes.

Urban woodlands do have one advantage over pristine forests in that the light levels are almost always greater, although use of a tripod should still be considered essential. This increased quantity of light reduces the time required for the film exposure and in turn can offer the chance to capture images without any unanticipated human subjects entering the frame. It is a good idea to visit local woods in order to practise your photography techniques. This means that ultimately you will have fewer lost or poorly composed shots when you do finally get to visit more wild forests or rainforests. If you consider that it is often an unrealistic option to revisit such locations, it makes sense to practise closer to home.

Wide-angle lenses are very useful for forest photography, as they allow you to portray the whole scene. As always, when using this kind of lens, it is essential to have some point of interest in the foreground to draw the eye into the composition. You will find that fallen down trees, boulders or streams make ideal subjects.

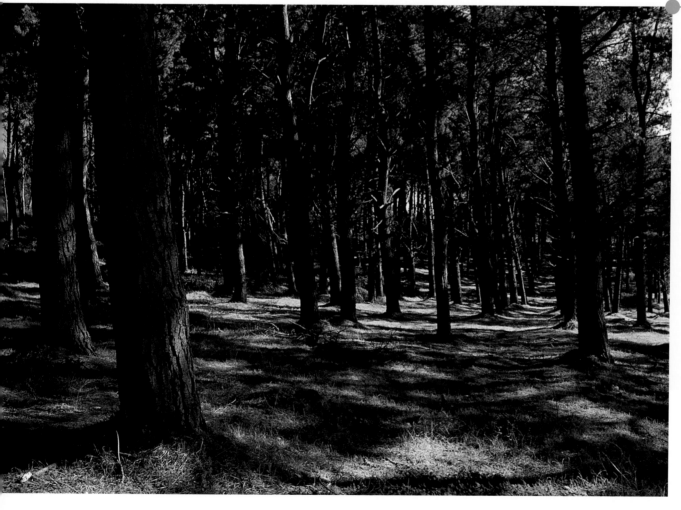

A miniature spirit level is essential for the forest photographer. A spirit level should be used to ensure that not only are the trees vertically level but also the angle of the camera is perfectly horizontal, ensuring the avoidance of converging verticals. ***Parco Naturale Del Complesso Lacuale Di Bracciano E Martignano, Italy – 1/2sec at f19, 35–80mm lens, combined 81A and polarizing filter, tripod, Canon EOS 300***

This small patch of woodland cannot be described as a true wilderness area although it is definitely very wild. Located less than a few miles from the bustling city of Newcastle-upon-Tyne, in North-East England, Holywell Dene is a popular recreational spot for local residents and can provide ample image opportunities for both local and visiting photographers. Although I normally prefer to photograph woodlands under flat, diffused lighting conditions, on this occasion the brief illuminating light has enhanced the image, isolating pockets of trees and giving the final composition a true feeling of depth. **Holywell Dene, Northumberland, England – shutter speed not recorded, at f/16, 80mm lens, polarizing and 81B filter, tripod, Mamiya M645J**

Take the time to explore your location before taking a picture. More often than not, you will find that the perfect subject appears before you when you least expect it. The key is to not look too hard. As with any aspect of wilderness photography, a little patience is required. Explore the textures and patterns created by the woodland, and when you find a likely candidate, set up your tripod. Next, examine every corner of the viewfinder to ensure that there are no distractions in the composition. A miniature spirit level can be useful in avoiding converging parallels, often found when photographing woodlands. Work with the lens set to a small aperture (I normally like to work at around

f/19), to maximize the depth of field of the composition. Finally you should take a spot-metered exposure reading from an evenly lit, mid-tone tree before proceeding to trigger the shutter release.

Unfortunately, urban woodlands can sometimes appear to be a little contrived compared to their wild counterparts. You may well find that you cannot compose a satisfactory photograph using a traditional viewpoint, so experiment. For example, try tilting your camera lens upward towards the forest canopy – a particularly effective technique that can be utilized in virtually any variety of woodland.

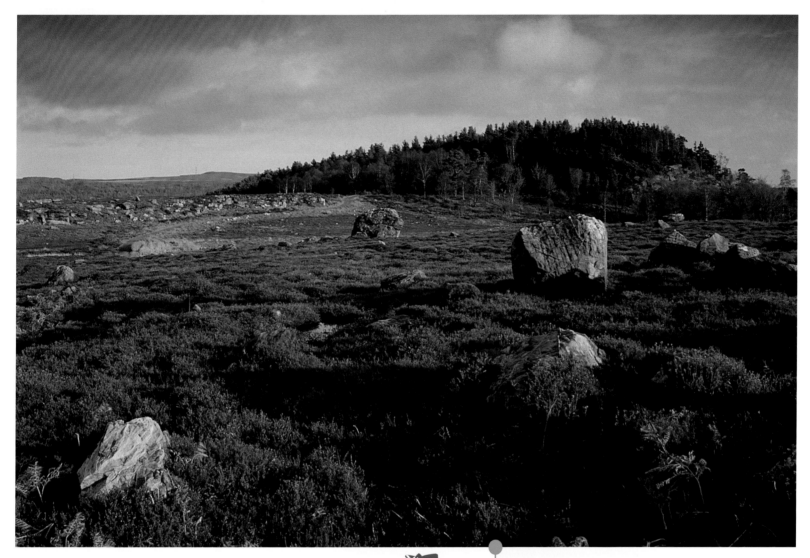

Moorland scenes

The impression of vast, hostile landscapes such as deserts
and plains can be gained from far more accessible open
areas with clever framing and outstanding illumination.
Only soft, low light will accentuate the subtle features of a
rolling landscape or, in the case of flat scenes, provide
colour interest to an otherwise featureless image. The use of
an interesting cloud formation in the sky can also add
much drama to the composition, however plain or pale
skies should be tightly cropped or even omitted.

TIPS

A composition with a
low horizon will
convey a feeling of
wilderness as
opposed to the
intimacy of a more
tightly framed
landscape.

*The moorlands to be found in Britain, offer the
photographer a chance to capture images of a
barren landscape, similar to the likes of deserts and
plains but with the benefits of being in close
proximity to human habitation.* **Rothbury,
Northumberland, England – 1/2sec at f/19, 35–80mm
lens, combined 81A and polarizing filter, tripod,
Canon EOS 300**

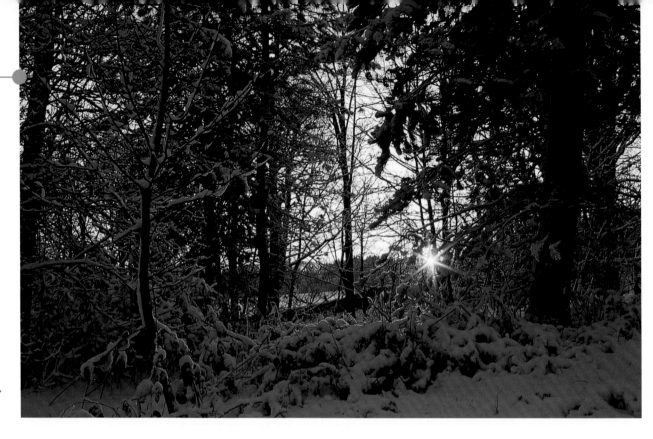

*Snow will transform virtually any scene. A fresh snowfall is very effective in 'hiding' manmade objects and also for injecting something of a wilderness feel into the picture. In fact the composition of this photograph would have failed if it had been captured during different weather conditions. Here the light-reflective quality of the fresh snow has lifted the picture, rescuing it from what would have otherwise been a dark and somewhat featureless landscape. **Baggeridge Country Park, West Midlands, England – 1sec at f/22, 28–70mm lens, tripod, Canon EOS 600***

This type of scenery can be transformed in the months of winter, especially if you choose to visit the location shortly after a fresh sprinkling of snow, when human constructions can start to become obscured or even, after a particularly heavy snowfall, completely hidden. Again, it is good practice to photograph snow in locations closer to home, with the photographer having plenty of time to consider the compositional elements and relevant exposure techniques.

National parks

Throughout the world there are national parks that have populated areas within them. Many of these areas were designated as national parks to help control the expansion of human dwellings into the neighbouring wilderness. This type of national park can offer the photographer the best of both worlds, providing a chance to record breathtaking wilderness views while having a base with hotels, restaurants and shops.

However there is a price to pay. Obviously people-free shots are more difficult to find in an area that is easily accessible.

The human traffic may have eroded the landscape or marked it with bitumen paths and roads. There is also a need for fences and information signs, reducing the number of photographic viewpoints available. However, it should be remembered that the national park system was designed to protect and conserve these landscapes, ensuring that they will be enjoyed by future generations. The photographer should observe all signs and never cross over a fence in search of the perfect picture.

National parks near urban settlements sometimes also make a good starting point for a photographer wishing to visit true wilderness. If you are a first time visitor to an area or country, the parks can offer you the opportunity to acclimatize to the region, essential if you are jet-lagged after a long-haul flight, as well as the chance to identify and photograph key elements of the location's characteristics. It is also common for some of the world's national parks to be gateways to some areas of spectacular wilderness although human traffic, tourism in particular, will probably be greater than in other untouched areas.

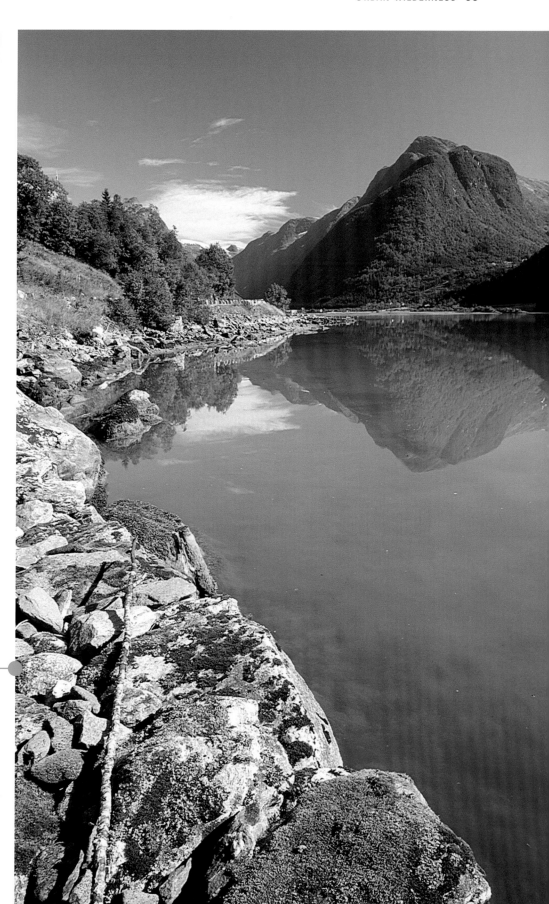

We reached the island of Perhentian Kecil in Peninsular Malaysia late in the afternoon. As soon as we reached the island we realized that it was something of a tourist destination and that the choices of accommodation may be limited. As expected, we spent the next couple of hours walking along the length of the beach hoping to find some basic accommodation in which to spend the night. We then resorted to plan B; the tent. Even then we found the official campsite full and the majority of the landowners unwilling to let us camp on their land. However, in the end we were lucky, especially as a tropical storm hit the island that night. Unfortunately, many others were not as prepared and had to spend a very wet night sleeping exposed on the beach with their rucksacks. It is this kind of situation that makes us glad that we carry a tent with us everywhere.

The main consideration for the photographer wishing to capture wilderness images in these and other near-urban environments is the obligation to pay closer attention to composition and the photographic elements required to produce outstanding photographs. The quality of light will need to be exquisite and a good, reliable exposure metering technique is imperative. Above all, these photographic practices will demonstrate to you that successful photographs can be composed and created at any location.

Although national parks make ideal locations for the wilderness photographer, the immediate fringing landscape should not be ignored. Here I used a wide-angle lens to create a sweeping view of the landscape of Fjæland, the gateway to Norway's spectacular Jostedalsbreen National Park. **Fjærlandsfjordan, Fjæland, Norway – 1/3sec at f/19, 24mm lens, combined 81A and polarizing filter, tripod, Canon EOS 300**

ARCTIC

NORTH AMERICA

EUROPE

AFRICA

SOUTH AMERICA

ANTARCTIC

Pristine wilderness locations

Many of the world's most spectacular places have had their presence guaranteed for future generations by being designated as national parks. Yellowstone National Park was the world's first such area, with legalisation passed in 1872 that protects its flora, fauna and natural features. This important step paved the way for similar parks in Australia (The Royal National Park – 1879), Canada (Banff National Park – 1885) and New Zealand (Tongariro National Park – 1887). Over the years many more areas have become national parks – a process which still continues today with locations such as the Rakiura National Park in New Zealand and Loch Lomond in Scotland becoming protected areas.

Not all of these national parks can be considered as true, pristine wilderness as in some cases their protection was simply enforced too late. One of the designation of the first national parks in England, the Lake District National Park, was not formed until 1951, some 79 years after the world's first national park. Even as the park was formed, loop-holes in the legalisation meant that properties were built and land rights issued, most having a detrimental effect to the area.

Unfortunately there are still many places in the world that are not protected and are at the mercy of building developers, tourism and human greed. Nothing is certain; we can only strive to protect and conserve these areas and, through photographs, promote their beauty and the value of keeping them in that state.

The seven continents of our world are constantly changing – some due to natural phenomena, others because of human intervention. Hopefully the last few remaining pockets of pristine wilderness will remain with us forever.

Towards the end of our hike along the Thornsbourne track on Hinchinbrook Island National Park in Australia, we decided to take an excursion to Sunken Reef Bay where we were to spend the final nights of our stay camping on the beach. We could not believe our eyes when we finally entered the location after a steep descent through pristine Australian wilderness, only to find a white sand beach literally covered in litter. It was a stark reminder of the detrimental aspects of civilization in what should have been a beautiful and unspoilt place. It soon became apparent that the empty tins, fishing lines, bleach bottles, shoes and more had been washed up from man's global rubbish dump, the sea. Even Hinchinbrook Island, a true wilderness area and protected in its own right as a national park, is not safe from the damaging presence of mankind.

ASIA

AUSTRALASIA

Australasia

With the split of the ancient southern continent, Gondwanaland, over 100 million years ago, came the birth of the world's largest island, Australia, and the formation of another unique landmass, New Zealand. Samoa, Tonga and Fiji are some of the other Australasian islands formed from the break up of Gondwanaland.

The majority of Australasia's landmass could be considered as pristine wilderness. The most famous island 'down under', Australia, is home to the oldest and most stable landmass in the world. Additionally, much of this landscape is also some of the most inhospitable on the planet, meaning human development is limited.

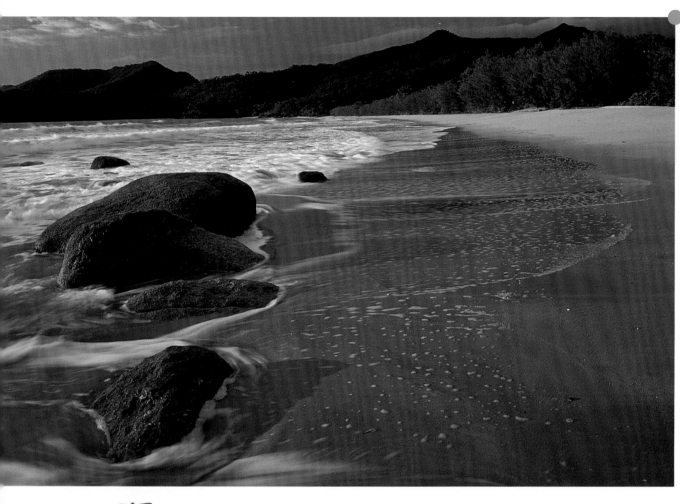

Hinchinbrook Island National Park, Queensland, Australia – 1/6sec at f/19, 28–70mm lens, polarizing filter, tripod, Canon EOS 300

At present there is only one area designated as a national park within the territories of the islands of Independent Samoa. This park represents a diverse cross-section of the prominent features of the picturesque island of Upolu. *Mataloa River, O Le Pupu-pu'e National Park, Upolu, Independent Samoa – 4sec at f/19, 24mm lens, polarizing filter, tripod, Canon EOS 600*

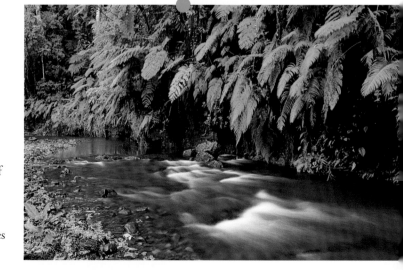

TIPS

Areas receiving high influxes of tourism are best photographed early morning or late evening. The long shadows cast by the soft sun will also greatly benefit compositions.

The landscapes to be found in Australia are amazingly diverse, with the vast and mainly flat outback dominating the majority of the country. This flat expanse of level terrain is also home to the world's largest single rock – Uluru, formally known as Ayers Rock. But this is by no means the only feature of interest to the photographer visiting the outback. It is easy to understand how the Devil's Marbles obtained their somewhat fearful name, enormous boulders scattered throughout a relatively small area in the outback, almost as if Beelzebub had dropped them there himself. The spectacular limestone monoliths of the Pinnacles Desert, found deep within Nambung National Park, Western Australia, are another such intriguing natural feature providing numerous opportunities for wilderness photography.

Australia is also home to vast tracts of pristine rainforest. The Daintree National Park in North-East Queensland offers the chance to photograph excellent examples of ancient rainforest, without the access problems to be found when visiting the wilderness far north in the Cape Tribulation area.

New Zealand on the other hand has no such predators. Here it is the landscape and the unpredictable climate which are life-threatening. New Zealand is an incredibly diverse location and its relatively small size compared to Australia make the areas of wilderness more easily accessible to most, and less dependent on the transport options available.

New Zealand is predominately divided into two, with the north island being host to the majority of the country's population. Furthermore, this is also home to most of the country's thermal areas. Tongariro National Park is one of these dramatic, surreal landscapes, offering the chance to photograph extinct, dormant, and sometimes active volcanoes. This is also a major ski-field area, meaning the access to winter alpine areas can be made easier by the use of access roads and ski-lifts. Like the entire country's landmass, this park has a scattering of hiking tracks and

TIPS

When photographing near to rivers and estuaries, it should be remembered that most of the northern, tropical areas of Australia are home to saltwater crocodiles. They will attack and kill humans so it is imperative that the visitor is careful and does not enter the water under any circumstances and also does not camp or wash dishes close to water.

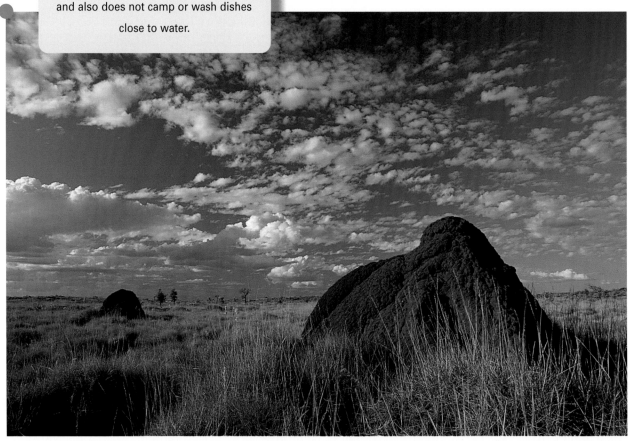

This could be considered as a stereotypical Australian scene. A classic example of the many termite mounds to be found scattered throughout the vast expanse of the Australian outback, one of the most inhospitable areas of wilderness to be found in the country. **The Pilbara, Western Australia, Australia – 1/2sec at f/19, 24mm lens, polarizing filter, tripod, Canon EOS 300**

back-country huts, making overnight trips a realistic option. However, there is a real safety issue from the threat of avalanches in the winter and spring months.

It is the larger south island where the visitor will find the stereotypical New Zealand landscape. Fiordland National Park is probably the most famous of these locations, a dramatic expanse of desolate wilderness, contributing to the immense Southwest New Zealand World Heritage Area. Covering an area of approximately 3 million acres, it is the largest of the country's national parks and probably one of the more photogenic, with many opportunities available for the photographer. These include lush rainforests, serene fiords and spectacular glacial carved valleys. It is also a hiker's paradise, with numerous walks scattered throughout the park as well as many overnight routes. The Milford track is one of the most famous and has been described by many as the finest walk in the world.

There are a scattering of other smaller islands throughout Australasia. These islands of paradise will also offer many opportunities for photography although local customs will need to be observed.

For example, on the islands of Western Samoa, the problems of accessing a location are huge. This is due to the majority of the country's landmass being owned by local villages. Considering that most of the country's inhabitants receive little or no income from employment, it is not surprising that the locals should wish to make money from tourism. This means that the visitor to a waterfall will have to pay a viewing fee to the natives, as will the photographer visiting a pristine beach. Although this may not sound a problem, the friendly locals like to guide you to a location, meaning that you are not in a position to spend hours practising your photography. Subsequently, people-free shots also become more difficult.

TIPS

When visiting any alpine area in New Zealand, it is essential to contact the local Department of Conservation office before heading into the back-country.

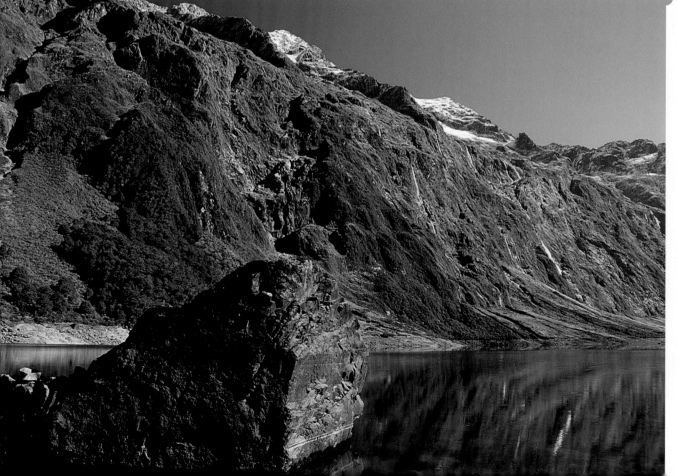

There are many day walks in Fiordland, which can offer the photographer a multitude of opportunities. Here, the still waters of Lake Marion perfectly reflect the surrounding landscape. If a wind had been present when I photographed the location, I would have been forced to use a faster shutter speed to help freeze the movement of the water.
Lake Marion, Fiordland National Park, South Island, New Zealand – 1/3sec at f/19, 24mm lens, polarizing filter, tripod, Canon EOS 600

North America

North America stretches across a huge area, from the Queen Elizabeth Islands found within the natural confines of the Arctic Ocean, to the Caribbean delights of the southern coastal districts of the Mexican Yucatan Peninsula and the islands of Jamaica and Puerto Rico. This continent has something to offer to any visiting wilderness photographer, irrespective of their preferred working environment.

Arctic Ocean

Beaufort Sea

GREENLAND

Baffin Bay

U.S.A.

Great Bear
Lake

Great Slave
Lake

Labrador Sea

Lake
Athabasca

Hudson
Bay

CANADA

Pacific Ocean

Lake
Winnipeg

Gulf of
St. Lawrence

Lake
Superior

Lake
Huron

Great Salt
Lake

U.S.A.

Lake
Michigan

Lake
Ontario

Lake Erie

Atlantic Ocean

MEXICO

TROPIC OF CANCER

Gulf
of
Mexico

BAHAMAS

CUBA

DOM. REP.

JAMAICA

HAITI

BELIZE

GUATEMALA

HONDURAS

Caribbean Sea

EL SALVADOR

NICARAGUA

Lake
Nicaragua

COSTA RICA

The most extreme wilderness to be found in Canada is within the Northwest Territories. Boasting scenes such as tundra plains reaching the Arctic Ocean and ice fields such as the ones to be found within the boundary of Kluane National Park, the area offers numerous photographic opportunities. However the problems of accessing such wilderness means that many visitors to the country prefer to visit more readily available locations. Although these alternative landscapes are by no means any less majestic, they may be harder to capture without the inclusion of people.

The Canadian Rockies are one such location. The sprawling Rocky mountain range stretches from wild North-West Canada through to the South-Western states of the USA, offering varied photographic opportunities along the way. The Canadian national parks of Banff, Jasper, Yoho and Kootney are all good places to start exploring the wilderness of the Canadian Rockies, with the four parks collectively forming a 20,155 square kilometre (7782 square mile) World Heritage Site, hopefully ensuring an unspoilt landscape for future generations.

Towards the east of the country, and less than 325 kilometres (201 miles) from the capital, Toronto, Algonquin Provincial Park has something to offer any wilderness photographer. Covering an area of 12,525 square kilometres (4836 square miles), there are numerous opportunities available for exploration, be it by canoe or by foot. The park and the Temagami area in general offer a good representation of the many varied landscapes to be found spanning the immense landmass of Canada, and numerous options for overnight stays.

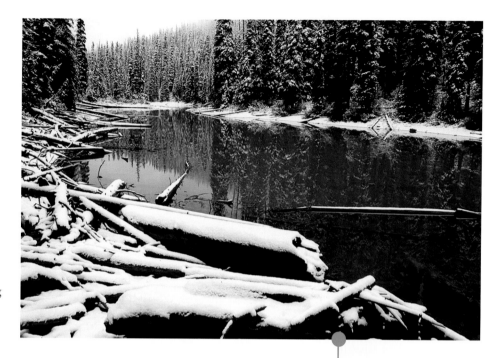

A very serious danger does however exist for the photographer wishing to stay overnight in the Canadian wilderness, and also in many areas of the USA. The brown and grizzly bears are both present and care must be taken if planning to spend a night under the stars. Needless to say, care must also be taken if planning a day hike within the wilderness. The visitor should ensure they wear bear bells, which can be found for sale throughout the country, in order to alert the bear to your presence and hopefully divert them from your path. Although bears are killers, they will not normally attack unless surprised by a human in a chance encounter, although this is not always the case.

TIPS

If the plan is to spend a night outdoors, the visitor must never leave food within the tent as bears have a highly acute sense of smell and will be attracted to the free feast. Any food remaining should be tied high in a tree, a safe distance away from the campsite.

*A spring snowfall coats a typical forest-clad valley, to be found within the boundaries of Yoho National Park, forming part of the Canadian Rockies World Heritage Site created in 1984. **Yoho Valley, Yoho National Park, British Columbia, Canada – shutter speed not recorded, at f/16, 28–70mm lens, Nikon 801s.** Photographer: Shaun Barnett*

A small lake offers the visitor an insight into the beautiful and spectacular panoramas to be found within this national park, which is located a short drive from the hectic city life of Los Angeles. **Santa Monica National Park, California, USA – 24mm lens, polarizing filter, tripod, Canon EOS 600**

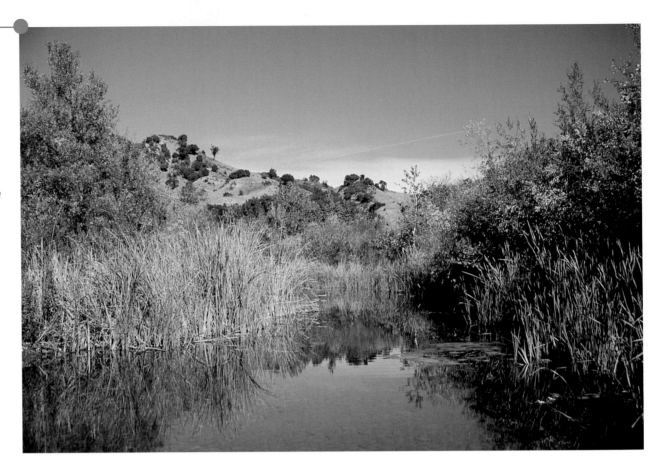

Being home to the world's first national park, it is of little surprise that the United States is comprised of some of the world's most spectacular landscapes. Alaska, the USA's northernmost state, is probably the country's most famous wilderness destination. Virtually all of Alaska's landmass could be considered as a true wilderness destination. As ever, the national parks of the country make good starting points for photography, such as the ice fields, canyons, mountains and glaciers of Wrangell-St Elias National Park which is situated alongside the Canadian border.

The list of locations for wilderness photography in mainland USA is virtually infinite. Not only is the country home to some of the most dramatic national parks to be found on the planet, it can also boast to playing host to some true wilderness areas. The hoodoos of the Grand Staircase Escalante wilderness make fascinating subjects, as do the mountains of the Collegiate Peaks Wilderness Area. As well as these, the United States is home to some of the world's most famous landscapes including the natural wonder of the Grand Canyon.

Heading south from the states, Mexico straddles the divide from North to Central America. Mexico itself is home to some hidden photographic gems. Baja California, the world's longest peninsula at 1288 kilometres (800 miles), provides a wild landscape comprising cactus-covered desert, contrasting with the azure blue colours of the many stretches of pristine coastline.

The island of Hawaii, also known as 'the big island' is the largest and youngest of the Hawaiian group of islands. Its landscape is a mixture of both dormant and active volcanic activity, with current eruptions contributing to its continually growing landmass. **The Big Island, Hawaii, USA – 24mm lens, polarizing filter, tripod, Canon EOS 600**

In stark contrast, southern Mexico is a landscape composed of mountains and rainforest. The rising mountain range which includes many dormant and active volcanoes, stretches across the length and breadth of the Central Americas. It is possible to climb many of these landmarks although care must be taken and an awareness of political situations maintained. Central America has long had a chequered reputation with travellers due to problems such as theft and muggings.

Over the years eco-tourism has become increasingly big business for some of the residents of Central America. This means that the photographer can safely visit many areas on dedicated trips, although independent travel will ultimately provide more photographic opportunities. Areas to consider visiting include the Mountain Pine Ridge in the Maya mountains of Belize, La Tigra Cloud Forest in Honduras and the Volcán Masaya National Park in Nicaragua.

South America

The landscape of South America consists of many outstanding features, including the world's highest waterfall, the world's greatest river basin and what has to be considered as one of the world's more dramatic mountain ranges.

Caribbean Sea

VENEZUELA

GUYANA

SURINAME

FRENCH GUIANA

COLOMBIA

EQUATOR

ECUADOR

PERU

BRAZIL

BOLIVIA

TROPIC OF CAPRICORN

PARAGUAY

CHILE

Pacific Ocean

URUGUAY

South Atlantic Ocean

ARGENTINA

FALKLAND ISLANDS

SOUTH GEORGIA ISLAND

The continent is physically separated from southern Central America by an area of pristine wilderness known as the Darién Gap. Bridging the countries of Panama and Columbia, it is not recommended for the casual photographer or traveller to attempt the route by land, even though the area has been designated as a national park by the authorities of both countries, as well as being listed as an important world heritage site. The reason for not visiting this area is due to personal safety, as it is home to smugglers, bandits and similar criminals.

The western margin of the South American continent is dominated by the sprawling expanse of the Andes mountain range. Stretching from the country of Venezuela in the north, to Patagonian Argentina in the south, the alpine areas present many possibilities for the high-altitude hiking photographer, although most will demand the hiring of a guide or participation in an organized group. The photographer intending to hike at high altitudes will also be required to follow the necessary procedures to help eliminate the possibility of altitude sickness.

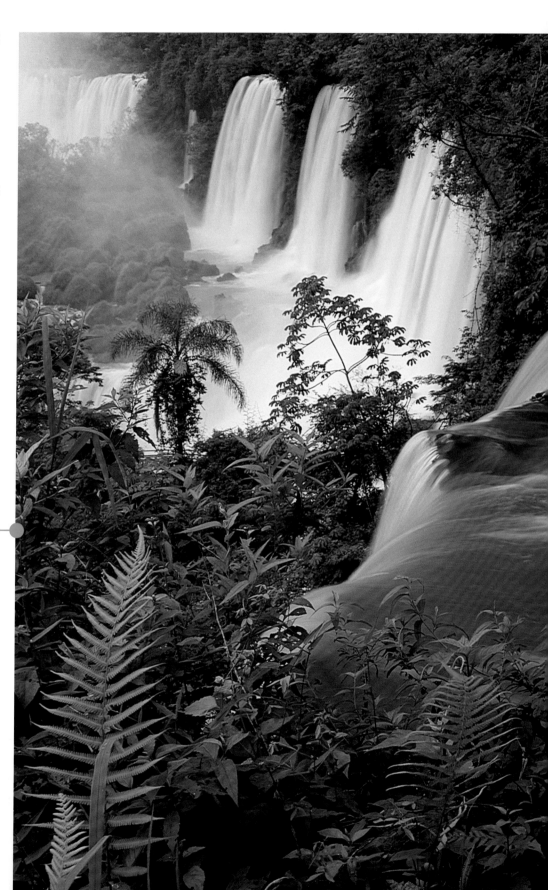

The ethereal flow of the fast waters of the Iguazu Falls, perfectly complemented by the greens of the engulfing forest. **Iguazu Falls, Iguazu Falls National Park, Misiones, Argentina – shutter speed not recorded, at f/16, 28–70mm lens, Nikon 801s.** *Photographer: Shaun Barnett*

The world's driest desert, the coastal Atacama, spreads from northern Chile to northern Peru, lying within the rain shadow of the high Andes – another reason why photographing this mountain range is a must. However, there are many other opportunities to photograph alpine landscapes throughout the continent. In Columbia, the Sierra Nevada de Santa Marta mountain range rises dramatically from the coastline of the Caribbean to a height which measures some 5775m (18,942ft) at points making it the world's highest coastal mountain range. Cerro Aconcagua, the western hemisphere's highest summit at 6962m (22835ft), is also found within the boundary of the continent, in the southern country of Argentina.

Warm evening light illuminates the peak of Volcan Villarrica, high above the surrounding, low-lying blanket of cloud. **Villarrica National Park, Pucon, Chile – shutter speed not recorded, at f/11, 75–300mm lens, Nikon 801s.** *Photographer: Shaun Barnett*

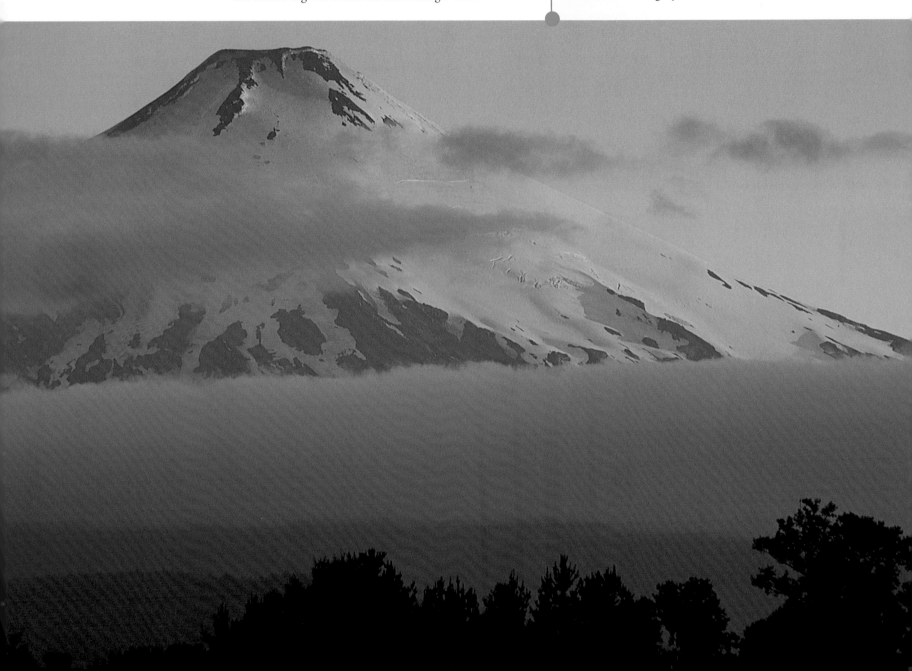

The nature-loving wilderness photographer will also not be disappointed by the continent, with the opportunity to visit the pristine Galápagos Islands or the wild Falkland Islands – both offering the chance to capture images of a true unspoilt landscape that is also home to a wealth of unusual wildlife. The great Amazon basin will also appeal to the visitor although pre-planning is essential. The rainforests of the Amazon are definitely not for the faint-hearted, with the seemingly endless list of diseases spread by mosquitoes making the use of repellents essential. With the rainforests of the Amazon basin being home to one fifth of the world's total of higher plants, it is of little surprise that the forest is home to a vast array of wildlife. From the likes of ticks and leeches to the world's largest snake, the anaconda, the rainforests of the Amazon demand total concentration on the part of the wilderness photographer. This area is possibly the world's greatest expanse of tropical wilderness – common sense is imperative for survival in this kind of terrain.

Considering the amount of water to be found throughout most of the continent, it is little surprise that South America is home to an abundance of waterfalls – the most famous being the Angel Falls in Venezuela. Named after an American bush pilot and not a divine messenger as one might expect, these falls are the world's highest at a total of 979 metres (3211ft), with an uninterrupted drop of some 807 metres (2646ft) into the immense Devil's Canyon (Cañón del Diablo). The falls are best visited in the months of June to December, when the water levels are at their highest, although the actual photographic conditions can prove to be less favourable. Reaching the falls will demand extensive pre-planning with the chartering of a light aircraft or boat being a necessity to reach the falls from Canaima. Other recommended waterfalls within the continent include the Iguazú Falls in Argentina and the Cachoeira da Primavera, found within the beautiful Parque Nacional da Chapada Diamantina in Brazil.

Africa

Home to the world's largest game reserves, this continent is more famous for its safari trips than its hiking routes. However these lands, the very cradle of mankind, can offer the photographer the chance to capture some extreme wilderness landscapes with just a little research and forward planning.

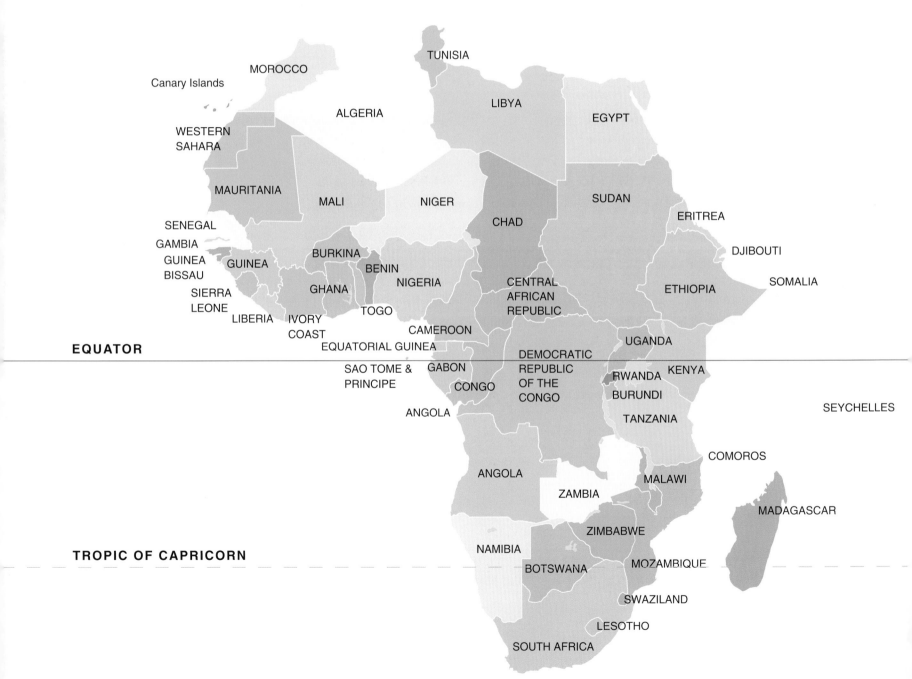

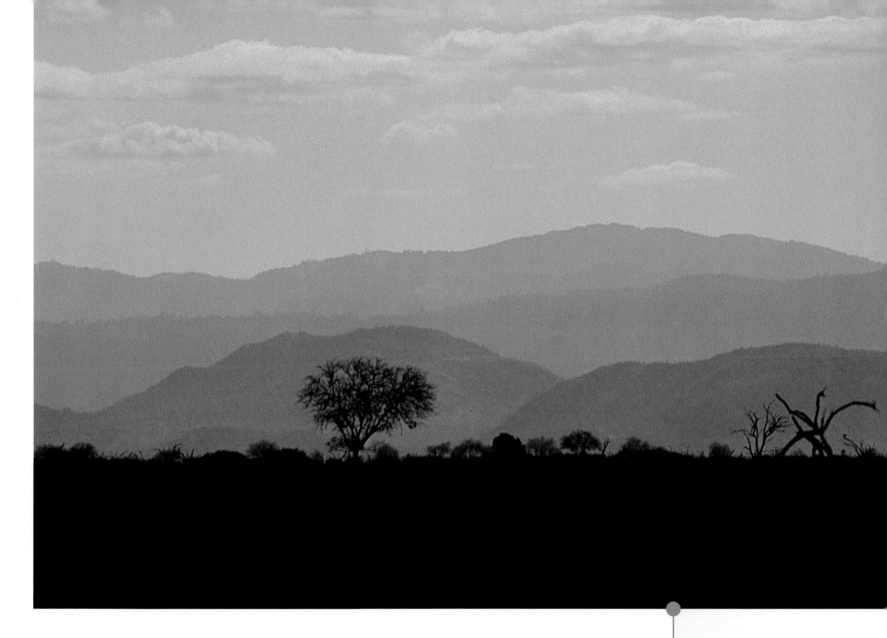

The country of Morocco offers a good introduction to the landscapes to be found within Africa. The world's largest and most famous desert, the Sahara, sprawls from Morocco across many of the other northern African countries, offering the opportunity to photograph the classic desert scene of forever undulating sand dunes. However, there is much more to photograph in Morocco.

The Atlas mountain range offers some of the best trekking opportunities in the continent. There are various routes scattered around the Toubkal area, as well as overnight huts run by the Club Alpin Français (CAF), available for use by both members and non-members. A popular route taken by visitors is the two-day ascent of North Africa's highest mountain, Jebel Toubkal, at 4167 metres (13,667ft).

South Africa, Eastern Cape – 125sec, at f/22, 18mm lens, 35mm, Fuji Velvia.
Photographer: Christopher Weston

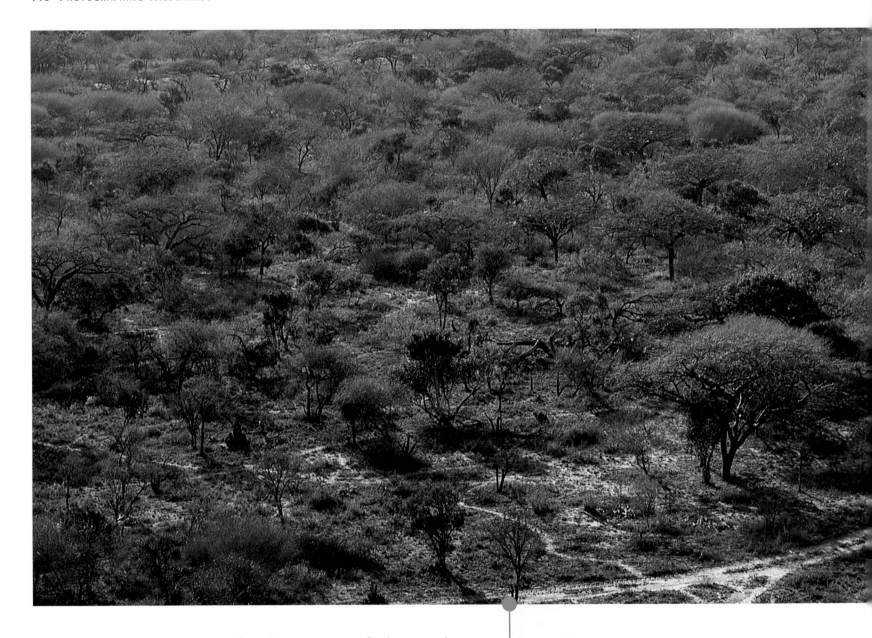

Kenya offers golden opportunities for the visitor who wishes to witness the spectacular African wildlife, as well as opportunities to climb some of the continent's highest peaks. In particular, the Mount Kenya National Park offers challenges for both hikers and climbers. To undertake some of these tracks requires hiring a guide, as do many hikes in Africa, whilst others are suitable for independent trekking. Additionally, there are also good alpine hiking opportunities in the Mt Mulanja area of Malawi, although the weather is notoriously unpredictable.

Kenya, Taita – 125sec, at f/16, 50mm lens, 35mm, Fuji Velvia.
Photographer: Christopher Weston

Nyika National Park, also in Malawi, offers many opportunities for lower-level hiking. Undulating upland hills and numerous wooded valleys are the dominating features of this pristine landscape. The famous displays of wild flowers to be found during the rainy season transform the grassy landscape into a mosaic of colour appealing to any wilderness photographer.

Yet again, wildlife spotting opportunities are good with the park's varied vegetation attracting the likes of zebras, roan antelopes and the occasional leopard.

To witness the stereotypical landscape of Africa, a visit to the national parks of Namibia is essential. As well as being host to one of the natural wonders of the world, Fish River Canyon, many of the country's parks offer good hiking opportunities. In addition, a permit is required for the visitor planning to walk the overnight track at Fish River Canyon and many of the other national parks found in the country. A strict number of hikers on the track is enforced, meaning a limited availability of permits. Consequently, the photographer may be required to book their place many months before walking the trail.

Asia

The visitor to Asia is greeted by an eclectic mixture of culture and nature, with this immense sprawling continent boasting some incredibly wild landscapes. For the photographer looking to immerse themselves in the wilderness of the continent there are many opportunities, be it a rainforest, volcano, tropical beach or mountain range, Asia will reward the determined traveller.

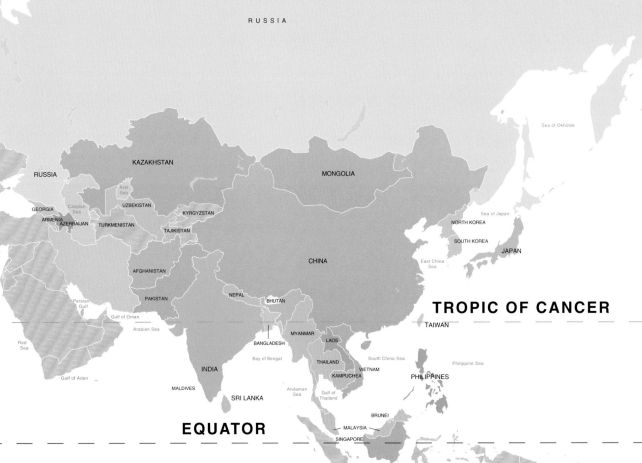

RUSSIA

KAZAKHSTAN

MONGOLIA

RUSSIA

GEORGIA
Caspian Sea
Aral Sea
UZBEKISTAN
ARMENIA
AZERBAIJAN
TURKMENISTAN
KYRGYZSTAN
TAJIKISTAN

NORTH KOREA
Sea of Japan
SOUTH KOREA
JAPAN

AFGHANISTAN

CHINA

East China Sea

PAKISTAN
NEPAL
BHUTAN

Persian Gulf

Gulf of Oman

TROPIC OF CANCER

Arabian Sea

TAIWAN

Red Sea

MYANMAR
BANGLADESH
LAOS

THAILAND
South China Sea
Philippine Sea

INDIA
Bay of Bengal
VIETNAM
KAMPUCHEA
PHILIPPINES

Gulf of Aden

MALDIVES
SRI LANKA
Andaman Sea
Gulf of Thailand

BRUNEI

EQUATOR

MALAYSIA
SINGAPORE

Java Sea
I N D O N E S I A

Arafura Sea

Timor Sea

Sea of Okhotsk

Bering

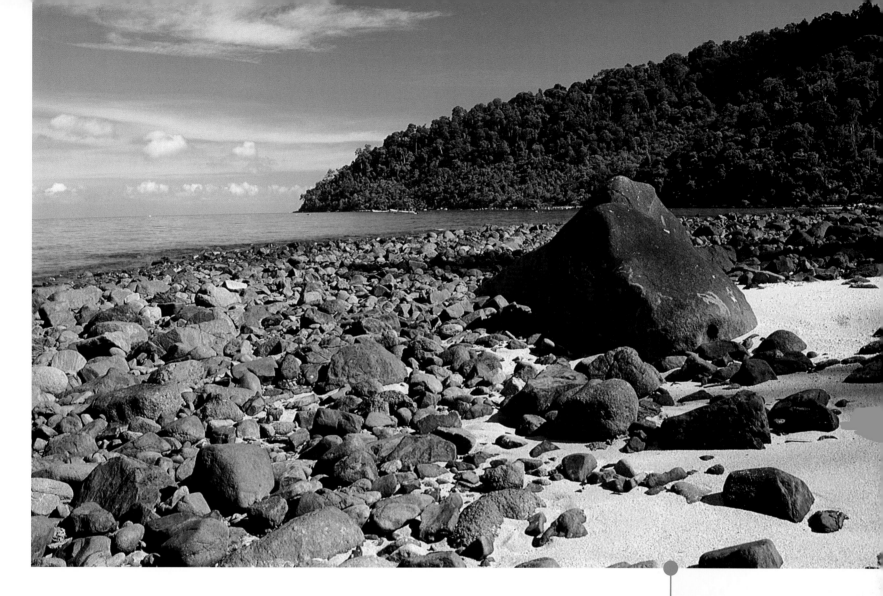

Probably the most famous location for trekking throughout the whole of Asia is the Himalayan mountain range, stretching west from eastern India to Afghanistan. Many hikers prefer to base their visits around the country of Nepal, where the routes are well mapped, many accommodation options are available and it is possible to glimpse a view of the world's highest mountain – Mount Everest. At some 8848 metres (29,021ft), an ascent of Everest is unfeasible for the casual visitor, as a trip will require extensive training and good weather.

There is no shortage of hiking trails available to the visitor to Nepal. Walks range from low- to high-level routes, with extra static days for acclimatization included in plans for walks to high altitudes. The country's classic routes include the nine-day Jomsom trek which features a journey into the world's deepest gorge – the Kali Gandaki gorge. Another popular route is another nine-day hike, the Jiri to Namche Bazaar trail, offering those ever-cherished views of Mount Everest. As well as these, there are numerous other equally spectacular hikes available for the wilderness photographer.

*Beautiful tropical beaches, such as the coastline of Tioman Island, are abundant throughout South-East Asia. **Air Batang, Tioman Island, Peninsular Malaysia – 1/2sec at f/19, 35–80mm lens, polarizing filter, tripod, Canon EOS 300***

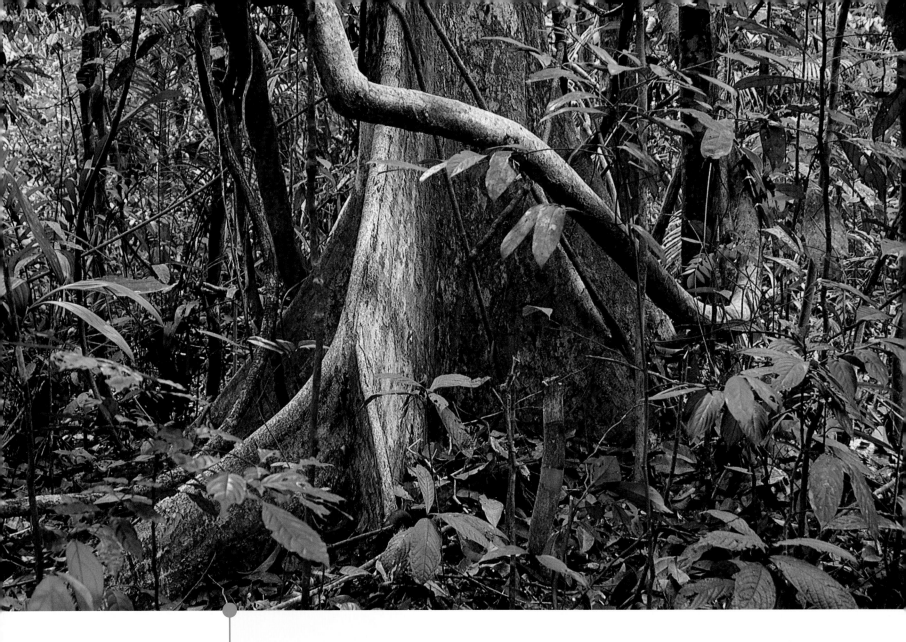

Photographing the ancient trees of this rainforest, considered to be amongst the oldest in the world, can prove to be difficult due to their sheer size. However, sometimes when composing an image, less can be more, demonstrated here with the selective cropping of the bottom portion of the trunk, helping to convey the grandeur of the tree to the viewer. *Taman Negara National Park, Pahang, Peninsular Malaysia – 20sec at f/19, 24mm lens, polarizing filter, tripod, Canon EOS 300*

In addition to the Himalayas, there are many other ranges scattered across Asia offering photographic opportunities. The Tian Shan mountains of Kazakhstan are one such location, as are the sacred peaks of China, although these offer fewer opportunities to photograph people-free landscapes. Even Thailand, more famous for its coastline and islands, can offer hiking opportunities within a spectacular mountain landscape.

Asia also plays host to some of the world's more unusual landscapes. The Mayon Volcano, found at the southern end of the island of Luzon within the Philippines, is the perfect volcanic cone. Another chain of islands, Indonesia, are home to the otherworld landscape of Bromo-Tengger-Semeru National Park – a spectacular volcanic panorama of smouldering peaks, to be found on the island of Java.

The beaches to be found across tropical Asia frequently capture the visitor's imagination and although many of the popular destinations receive huge influxes of tourists, it is still possible to find people-free viewpoints for wilderness photography. The list of beaches to visit is endless, including the likes of Goa in India, Tioman Island in Peninsular Malaysia, the entire Philippines island chain and Halong Bay in Vietnam.

It is claimed that Malaysia is home to the world's oldest rainforest. Preserved for future generations as the Taman Negara National Park, it offers numerous trails for the photographer wishing to explore this pristine rainforest. It is also possible to stay overnight in many hides scattered throughout the park where it may be possible to view tigers, elephants or panthers, although sightings are rare due to a dramatic decline in their numbers. The visiting photographer may also wish to scale Peninsular Malaysia's highest peak, Gunung Tahan – a 2187 metre (7173ft) ascent taking a nine-day return trip from the park's headquarters, although a guide is compulsory for this route. Another famous rainforest within the boundaries of political Malaysia is the area known as Borneo, home to numerous rare wildlife species including the orangutan and honey bear, as well as the world's largest flower, the rafflesia, easily sighted in the picturesque Rafflesia Forest Reserve.

The landscape of East Asia is a complete contrast to the continent's western lands. The Middle East is famous for its deserts, although the area does in addition boast some outstanding coastline. Photography is reknowned for being difficult in the countries of the Middle East and extensive research and foreward planning should be undertaken before embarking on a trip to the area.

Europe

The sprawling European continent offers varied opportunities for the wilderness photographer wishing to venture off the beaten track. The mainland, home to the world-famous mountain ranges of the Alps, can also lay claim to being the birthplace of skiing. An activity which developed in the lands of Scandinavia primarily as a result of the necessity to traverse the landscape rather than as a sporting pastime.

ICELAND

Norwegian Sea

North Atlantic Ocean

SWEDEN

FINLAND

NORWAY

Gulf of Bothnia

ESTONIA

Baltic Sea

North Sea

LATVIA

DENMARK

LITHUANIA

IRELAND

BYELARUS

U. K.

NETHERLANDS

English Channel

POLAND

BELGIUM

GERMANY

UKRAINE

LUXEMBOURG

CZECH REPUBLIC

SLOVAKIA

MOLDOVA

LIECHTENSTEIN

FRANCE

AUSTRIA

HUNGARY

SWITZERLAND

Bay of Biscay

SLOVENIA

ROMANIA

Black Sea

CROATIA

BOSNIA

SERBIA

ANDORRA

ITALY

Adriatic

BULGARIA

PORTUGAL

CORSICA

MONTENEGRO

MACEDONIA

TURKEY

SPAIN

BALEARIC ISLANDS

SARDINIA

ALBANIA

Tyrrhenian Sea

GREECE

Aegean

SICILY

Ionian Sea

CYPRUS

MALTA

Mediterranean Sea

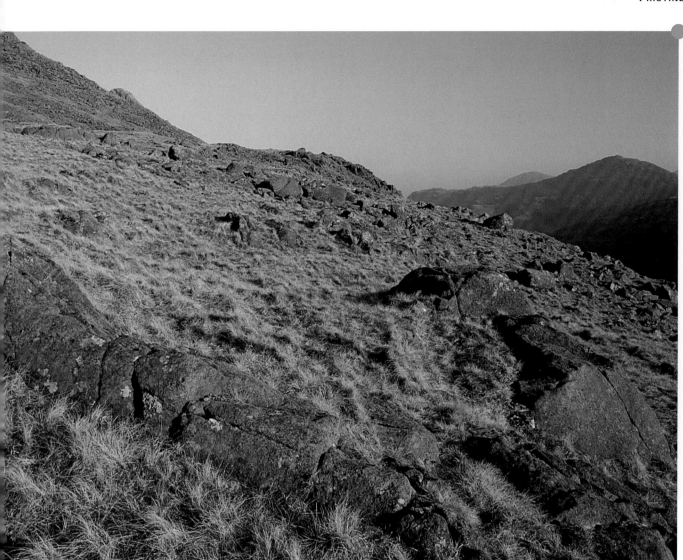

The English Lake District, home to the country's highest peak, Skafell Pike, is the largest and least developed region of mountainous landscape in the country. Here, soft late afternoon light illuminates the lichen-covered rocks of Martcrag Moor, a wild landscape that can be experienced whilst walking the long distance 'Cumbria Way' track. **Martcrag Moor, Lake District National Park, Cumbria, England – 1/3sec at f/19, 24mm lens, combined 81A and polarizing filter, tripod, Canon EOS 300**

The area known as Lapland, to be found in Northern Europe makes a good location for exploring the Arctic landscape that straddles the northernmost lands of the continent. In particular, the Lemmenjoki National Park in Finland can offer some of the most exhilarating opportunities for wilderness photography. Although only actually covering a small proportion of the park, there is an extensive array of trails available for the hiking photographer which, coupled with a large selection of free huts, make the park an ideal introduction to the landscape of the Arctic Circle.

The western fjords of Norway make an unbelievable location for picturesque landscapes. Here the photographer can capture scenes of idyllic fjords with dramatic mountain peaks rising sharply from the waters' banks. It may also be possible to witness the northern lights, a phenomenon that occurs across the entire north of the northern hemisphere. The *Aurora Borealis*, as it is scientifically known, is a mesmerizing spectacle of immense beauty, with shafts of coloured light appearing to dance against a clear backdrop of the northern stars. Although a fascinating subject for photography, many prefer just to watch the show.

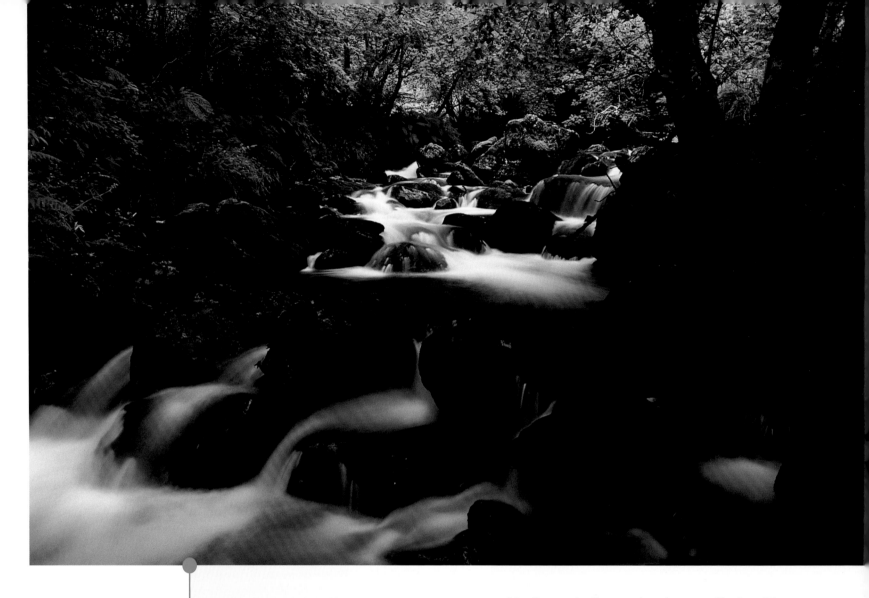

Incredibly, the majority of Norway's landmass can be considered as wilderness. For this shot of a fast-flowing stream near the tourist area of Flåm, I up-rated my ISO50 film to ISO100, which has increased colour saturation, as well as increasing the size of the film's grain. This technique is useful for some situations, especially in low levels of light. **Flåm, Sogn Og Fjiordane, Norway – 3sec at f/19, 24mm lens, combined 81A and polarizing filter, tripod, Canon EOS 300. Film rated at ISO100 and developing times extended to compensate**

Heading south, Germany has plenty to offer the wilderness photographer. Rising from the northern plains of the country, the Harz mountains have an organized choice of trails for one wishing to venture throughout the range. This area is also popular with cross-country skiers, a pastime that can be combined with photography to achieve memorable results. The key for the photographer wishing to integrate photography with skiing is that the equipment carried must be kept to a minimum. This means that the normally essential tripod should be left behind. To help achieve a steady platform for the camera, it is possible to use a hiking pole with a standard size camera thread fitted on the top, utilizing the pole as if it was a monopod.

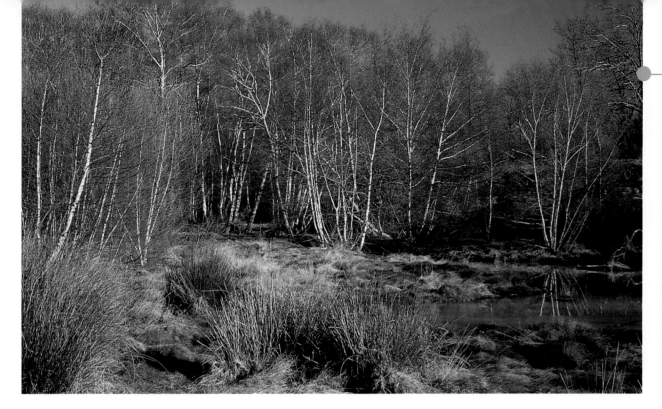

The thermal areas of this wild park make it a fascinating location for the photographer to visit. The added bonus is that it is situated only a short drive north of Rome. **Monumento Naturale Caldara Di Manziana, Italy – 1/3sec at f/19, 35-80mm lens, combined 81A and polarizing filter, tripod, Canon EOS 300**

The Pyranees National Park which runs along the French-Spanish mountains will also appeal to the alpine landscape photographer, as it is another area with a good network of trails and basic mountain huts. Similar opportunities abound in the area surrounding the glacial lakes of the Fagaras mountains in Romania and the entire Jura mountains range in Switzerland.

The highlands of Scotland, found within the British Isles, are famous with photographers throughout the world. Although often described as Europe's largest expanse of wilderness, the area has physically changed throughout the millennia as a result of human intervention. However, the vast stretches of moorland that were once forested do offer remarkable opportunities for the photographer, with the quality of Scottish light being particularly exquisite. Rannoch Moor is possibly the most famous location, although for this reason it is heavily photographed, making the search for alternative viewpoints imperative.

Tuscany in Italy is something of a Mecca for landscape photographers and although not all of it could be considered as pristine, there are numerous photographic opportunities available for the photographer willing to explore. The nearby island of Corsica, in the Mediterranean is also a hot-spot for both mountain and coastal landscapes. The vast expanses of pure white sand to be found on the island will compare to any to be found in the world, with the Mediterranean climate making favourable working conditions. The multicoloured granite landscape of the Les Calanche mountain range cannot be ignored for the photographer looking for something of a wilder landscape. The hiking opportunities include the 200 kilometre (124 mile) GR20 track following the island's continental divide from the north-west to south-east, passing through pristine wilderness including pine and beech forests, glacial lakes and peat bogs. During the months of May and June, the island receives the most guaranteed sun of the year, as well as being famous for its spectacular display of wild flowers.

Antarctica

The continent of Antarctica has to be considered as the wildest place on the planet. A vast landscape of snow and ice, the real achievement of visiting Antarctica is actually reaching it. Flights to the area are extremely expensive and the option of a long-haul trip by ship is often governed by the weather and ice. As there are no true habitations on Antarctica, apart from scientific research and oil drill parties, public transport to the continent is infrequent.

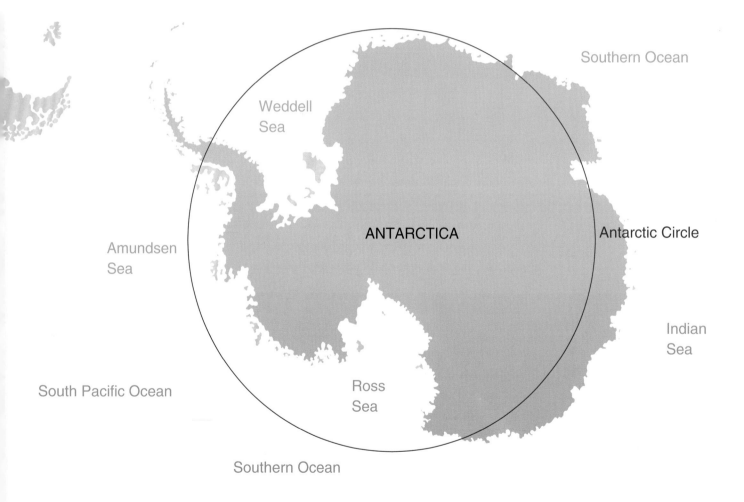

Atlantic Ocean

Southern Ocean

Weddell
Sea

ANTARCTICA

Antarctic Circle

Amundsen
Sea

Indian
Sea

South Pacific Ocean

Ross
Sea

Southern Ocean

But the visitor to Antarctica will not be disappointed as the oddities are endless. They include islands once mapped which suddenly disappeared, as well as the world's most isolated island – Bouvetoya, with as much as 93 per cent of the landmass totally covered by glaciers making a visit by man extremely difficult. Incredibly, not all of Antarctica is covered by ice, with areas known as 'oases' to be found in the Dry Valley. Here scientists believe that no rain has fallen for the last 2 million years. This area is home to a unique mixture of bacteria, fungi and algae to be found living within the rocks of the landscape.

In order to maximize the potential of a visit to Antarctica you will need to participate in an organized tour. Although tours can often be restrictive for photography in other continents, here they ensure that the visitor is able to reach the famous locations, such as the Kodak gap of the Lemaire Channel and the imposing mountainous and glacial landscape of Paradise Harbour. For the nature photographer, a trip to visit the large penguin colony to be found on Zavodovski Island may very well be the experience of a lifetime.

Snow cornice on the Efebus Glacial Tongue with the active volcano, Mt Erebus, backed by a plume on the horizon. Taken near midnight. **Ross Island, Antarctica – 1/30sec at f/11, 20mm lens, Nikon 8008S.** *Photographer: Ann Hawthorne*

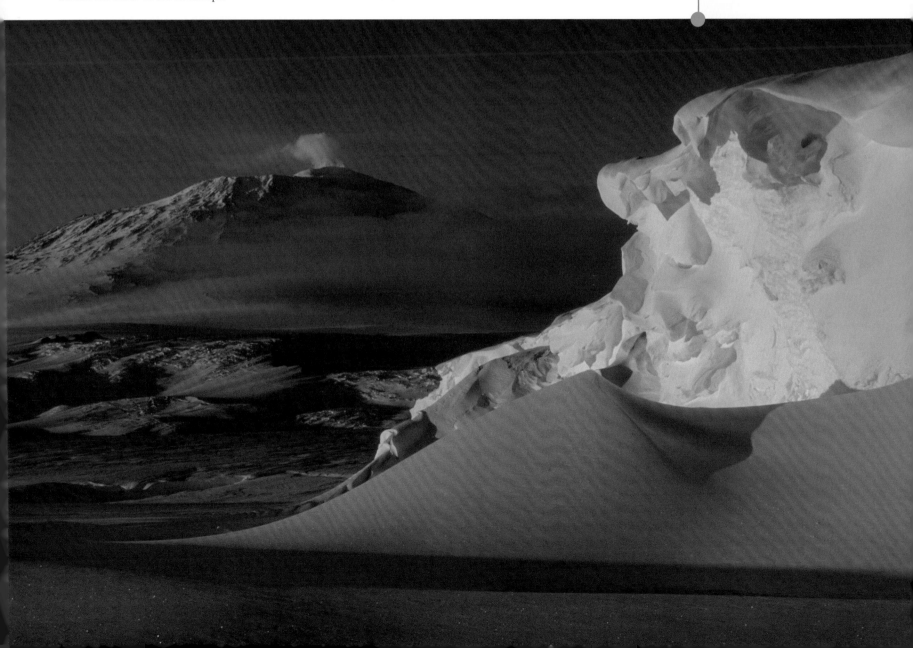

INDEX

TITLES AVAILABLE FROM
GMC PUBLICATIONS BOOKS

WOODCARVING

Beginning Woodcarving	*GMC Publications*
Carving Architectural Detail in Wood:	
The Classical Tradition	*Frederick Wilbur*
Carving Birds & Beasts	*GMC Publications*
Carving the Human Figure: Studies in Wood and Stone	*Dick Onians*
Carving Nature: Wildlife Studies in Wood	*Frank Fox-Wilson*
Celtic Carved Lovespoons: 30 Patterns	*Sharon Littley & Clive Griffin*
Decorative Woodcarving (New Edition)	*Jeremy Williams*
Elements of Woodcarving	*Chris Pye*
Essential Woodcarving Techniques	*Dick Onians*
Figure Carving in Wood: Human and Animal Forms	*Sara Wilkinson*
Lettercarving in Wood: A Practical Course	*Chris Pye*
Relief Carving in Wood: A Practical Introduction	*Chris Pye*
Woodcarving for Beginners	*GMC Publications*
Woodcarving Made Easy	*Cynthia Rogers*
Woodcarving Tools, Materials & Equipment	
(New Edition in 2 vols.)	*Chris Pye*

WOODTURNING

Bowl Turning Techniques Masterclass	*Tony Boase*
Chris Child's Projects for Woodturners	*Chris Child*
Contemporary Turned Wood: New Perspectives	
in a Rich Tradition	*Ray Leier, Jan Peters & Kevin Wallace*
Decorating Turned Wood: The Maker's Eye	*Liz & Michael O'Donnell*
Green Woodwork	*Mike Abbott*
Intermediate Woodturning Projects	*GMC Publications*
Keith Rowley's Woodturning Projects	*Keith Rowley*
Making Screw Threads in Wood	*Fred Holder*
Segmented Turning: A Complete Guide	*Ron Hampton*
Turned Boxes: 50 Designs	*Chris Stott*
Turning Green Wood	*Michael O'Donnell*
Turning Pens and Pencils	*Kip Christensen & Rex Burningham*
Woodturning: Forms and Materials	*John Hunnex*
Woodturning: A Foundation Course (New Edition)	*Keith Rowley*
Woodturning: A Fresh Approach	*Robert Chapman*
Woodturning: An Individual Approach	*Dave Regester*
Woodturning: A Source Book of Shapes	*John Hunnex*

Woodturning Masterclass	*Tony Boase*
Woodturning Techniques	*GMC Publications*

WOODWORKING

Beginning Picture Marquetry	*Lawrence Threadgold*
Celtic Carved Lovespoons: 30 Patterns	*Sharon Littley & Clive Griffin*
Celtic Woodcraft	*Glenda Bennett*
Complete Woodfinishing (Revised Edition)	*Ian Hosker*
David Charlesworth's Furniture-Making Techniques	
	David Charlesworth
David Charlesworth's Furniture-Making Techniques	
– Volume 2	*David Charlesworth*
Furniture-Making Projects for the Wood Craftsman	*GMC Publications*
Furniture-Making Techniques for the Wood Craftsman	*GMC Publications*
Furniture Projects with the Router	*Kevin Ley*
Furniture Restoration (Practical Crafts)	*Kevin Jan Bonner*
Furniture Restoration: A Professional at Work	*John Lloyd*
Furniture Restoration and Repair for Beginners	*Kevin Jan Bonner*
Furniture Restoration Workshop	*Kevin Jan Bonner*
Green Woodwork	*Mike Abbott*
Intarsia: 30 Patterns for the Scrollsaw	*John Everett*
Kevin Ley's Furniture Projects	*Kevin Ley*
Making Chairs and Tables – Volume 2	*GMC Publications*
Making Heirloom Boxes	*Peter Lloyd*
Making Screw Threads in Wood	*Fred Holder*
Making Woodwork Aids and Devices	*Robert Wearing*
Mastering the Router	*Ron Fox*
Pine Furniture Projects for the Home	*Dave Mackenzie*
Router Magic: Jigs, Fixtures and Tricks to	
Unleash your Router's Full Potential	*Bill Hylton*
Router Projects for the Home	*GMC Publications*
Router Tips & Techniques	*Robert Wearing*
Routing: A Workshop Handbook	*Anthony Bailey*
Routing for Beginners	*Anthony Bailey*
Sharpening: The Complete Guide	*Jim Kingshott*
Space-Saving Furniture Projects	*Dave Mackenzie*
Stickmaking: A Complete Course	*Andrew Jones & Clive George*
Stickmaking Handbook	*Andrew Jones & Clive George*

Storage Projects for the Router — *GMC Publications*

Veneering: A Complete Course — *Ian Hosker*

Veneering Handbook — *Ian Hosker*

Woodworking Techniques and Projects — *Anthony Bailey*

Woodworking with the Router: Professional

 Router Techniques any Woodworker can Use *Bill Hylton & Fred Matlack*

UPHOLSTERY

Upholstery: A Complete Course (Revised Edition) — *David James*

Upholstery Restoration — *David James*

Upholstery Techniques & Projects — *David James*

Upholstery Tips and Hints — *David James*

TOYMAKING

Scrollsaw Toy Projects — *Ivor Carlyle*

Scrollsaw Toys for All Ages — *Ivor Carlyle*

DOLLS' HOUSES AND MINIATURES

1/12 Scale Character Figures for the Dolls' House — *James Carrington*

Americana in 1/12 Scale: 50 Authentic Projects

 Joanne Ogreenc & Mary Lou Santovec

The Authentic Georgian Dolls' House — *Brian Long*

A Beginners' Guide to the Dolls' House Hobby — *Jean Nisbett*

Celtic, Medieval and Tudor Wall Hangings in

 1/12 Scale Needlepoint — *Sandra Whitehead*

Creating Decorative Fabrics: Projects in 1/12 Scale — *Janet Storey*

Dolls' House Accessories, Fixtures and Fittings — *Andrea Barham*

Dolls' House Furniture: Easy-to-Make Projects in 1/12 Scale — *Freida Gray*

Dolls' House Makeovers — *Jean Nisbett*

Dolls' House Window Treatments — *Eve Harwood*

Edwardian-Style Hand-Knitted Fashion

 for 1/12 Scale Dolls — *Yvonne Wakefield*

How to Make Your Dolls' House Special:

 Fresh Ideas for Decorating — *Beryl Armstrong*

Making 1/12 Scale Wicker Furniture for the Dolls' House — *Sheila Smith*

Making Miniature Chinese Rugs and Carpets — *Carol Phillipson*

Making Miniature Food and Market Stalls — *Angie Scarr*

Making Miniature Gardens — *Freida Gray*

Making Miniature Oriental Rugs & Carpets — *Meik & Ian McNaughton*

Making Miniatures: Projects for the

 1/12 Scale Dolls' House — *Christiane Berridge*

Making Period Dolls' House Accessories — *Andrea Barham*

Making Tudor Dolls' Houses — *Derek Rowbottom*

Making Upholstered Furniture in 1/12 Scale — *Janet Storey*

Making Victorian Dolls' House Furniture — *Patricia King*

Medieval and Tudor Needlecraft:

 Knights and Ladies in 1/12 Scale — *Sandra Whitehead*

Miniature Bobbin Lace — *Roz Snowden*

Miniature Crochet: Projects in 1/12 Scale — *Roz Walters*

Miniature Embroidery for the Georgian Dolls' House — *Pamela Warner*

Miniature Embroidery for the Tudor and

 Stuart Dolls' House — *Pamela Warner*

Miniature Embroidery for the 20th-Century Dolls' House — *Pamela Warner*

Miniature Embroidery for the Victorian Dolls' House — *Pamela Warner*

Miniature Needlepoint Carpets — *Janet Granger*

More Miniature Oriental Rugs & Carpets — *Meik & Ian McNaughton*

Needlepoint 1/12 Scale:

 Design Collections for the Dolls' House — *Felicity Price*

New Ideas for Miniature Bobbin Lace — *Roz Snowden*

Patchwork Quilts for the Dolls' House:

 20 Projects in 1/12 Scale — *Sarah Williams*

Simple Country Furniture Projects in 1/12 Scale — *Alison J. White*

CRAFTS

Bargello: A Fresh Approach to Florentine Embroidery — *Brenda Day*

Beginning Picture Marquetry — *Lawrence Threadgold*

Blackwork: A New Approach — *Brenda Day*

Celtic Cross Stitch Designs — *Carol Phillipson*

Celtic Knotwork Designs — *Sheila Sturrock*

Celtic Knotwork Handbook — *Sheila Sturrock*

Celtic Spirals and Other Designs — *Sheila Sturrock*

Celtic Spirals Handbook — *Sheila Sturrock*

Complete Pyrography — *Stephen Poole*

Creating Made-to-Measure Knitwear:

 A Revolutionary Approach to Knitwear Design — *Sylvia Wynn*

Creative Backstitch — *Helen Hall*

GARDENING

PHOTOGRAPHY

ART TECHNIQUES

VIDEOS

MAGAZINES

WOODTURNING ◆ WOODCARVING ◆
FURNITURE & CABINETMAKING
THE ROUTER ◆ NEW
WOODWORKING ◆ THE DOLLS'
HOUSE MAGAZINE
OUTDOOR PHOTOGRAPHY ◆ BLACK
& WHITE PHOTOGRAPHY
TRAVEL PHOTOGRAPHY ◆ MACHINE
KNITTING NEWS
KNITTING ◆ GUILD OF MASTER
CRAFTSMEN NEWS

The above represents a full list of all titles currently published or scheduled to be published.

All are available direct from the Publishers or through bookshops, newsagents and specialist retailers.

To place an order, or to obtain a complete catalogue, contact:

**GMC Publications,
Castle Place, 166 High Street, Lewes, East
Sussex BN7 1XU United Kingdom
Tel: 01273 488005 Fax: 01273 402866
E-mail: pubs@thegmcgroup.com**

Orders by credit card are accepted